The Beginner's Guide to
Chinese Painting

Farm Animals and Pets

by Mei Ruo

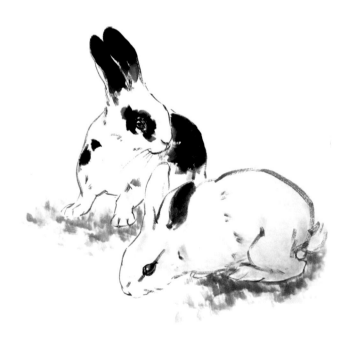

Better Link Press

This book is edited and designed by the Editorial Committee of *Cultural China* series

Managing Directors: Wang Youbu, Xu Naiqing
Editorial Director: Wu Ying
Editors: Yang Xiaohe, Susan Luu Xiang
Editing Assistant: Wu Yuezhou

Text by Mei Ruo
Translation by Yijin Wert

Interior and Cover Design: Yuan Yinchang, Zhong Yiming

ISBN: 978-1-60220-135-4

Address any comments about *The Beginner's Guide to Chinese Painting: Farm Animals and Pets* to:

Better Link Press
99 Park Ave
New York, NY 10016
USA

or

Shanghai Press and Publishing Development Company
F 7 Donghu Road, Shanghai, China (200031)
Email: comments_betterlinkpress@hotmail.com

Printed in China by Shanghai Donnelley Printing Co., Ltd.

3 5 7 9 10 8 6 4 2

Contents

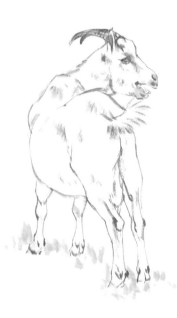

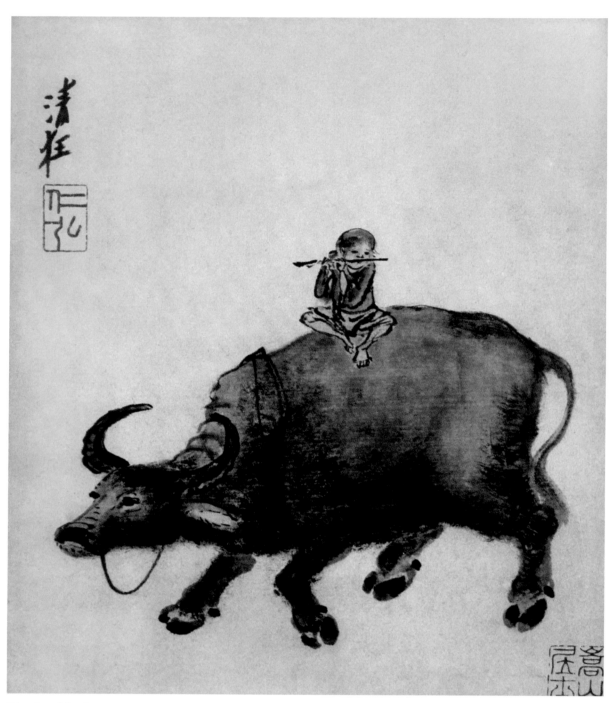

Playing Horizontal Flute on the Back of an Ox
Guo Xu (1456 – 1529), Ming dynasty
Ink on paper
29.9 × 25 cm
Shanghai Museum

Guo Xu was a native of Taihe, Jiangxi province. Specialized in
landscape and figure painting, he was an expert in painting with
the big *xieyi* style (great freehand style). This painting is one of
his outstanding art works, depicting an ox and a boy with vivid
brush strokes and unique ink tones.

Preface

Having to interact with animals everyday, our ancestors formed a close bond with them. They saw animals as their protectors and worshipped them as such. The earliest subjects to appear in ancient Chinese poems were animals and plants, and as a result, they became the earliest subject for Chinese paintings. The bird-and-flower paintings were separated from the figure and landscape paintings to form an independent genre that includes a wide range of natural topics, including flowers (plants), birds, fishes, insects, pets, mammals etc.

There are two challenging skills in creating successful paintings of animals:

First, illustrate the features of animals precisely. In order to paint a vivid portrait of an animal, you need to know its basic body structure, capture its unique features, and depict its most flattering pose and movement. If you have some basic training in art, you will not have any difficulty in reaching this level.

Second, master the special techniques in Chinese painting. With the development of art history in China, Chinese artists established several well-developed techniques. *Gongbi* or fine-brush is a meticulous and realistic technique, the opposite of the interpretive and freely expressive big *xieyi* style or great freehand style. The small *xieyi* style or slight freehand style is not as detailed as the traditional fine-brush style, nor is it liberal like the great freehand style. The fine-brush technique uses fine brushstrokes to paint precise and vivid details, whereas the great freehand style incorporates symbolism into the paintings. It puts emphasis on the spiritual aspect of paintings without creating fine details of the subject.

The slight freehand style not only focuses on painting the subject precisely, but also emphasizes on the spiritual aspect of the subject. This style suits the taste of everyone. This book focuses mainly on how to paint animals using the freehand style.

The three key elements of the freehand style representing the features of the Chinese brush painting are: (1) Use simple brush strokes to outline the body structure of the animal; (2) Highlight the unique features of the animal to show its characteristics; (3) Express the vital spirit of the subject through the eyes of the animal.

It will be very difficult for beginners or inexperienced amateur artists to master these three key elements. This book will introduce some basic painting techniques, which are the line drawing technique, the *du* painting style (coarse dot strokes), *simao* technique (feather-edging), and ink rubbing method. All the techniques share the same requirements—how to apply brush strokes and to control ink shading and the wetness of the ink. Besides mastering the painting techniques, it is also very important to observe animals frequently and practice sketching them. Once you master the painting techniques and the required knowledge of the animal features, you will be able to produce quality paintings.

The Beginner's Guide to Chinese Painting: Farm Animals and Pets introduces the techniques on how to paint popular livestock and pets, including cats, dogs, rabbits, roosters, ducks, pigs, goats, oxen, and horses. Some of these animals hold special meaning in Chinese culture and therefore, are deeply loved by the Chinese people.

Rooster

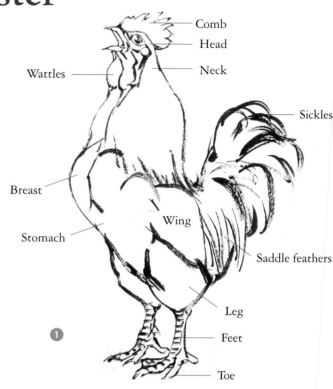

The most popular farm raised fowls that people are familiar are chickens. In the Chinese language, the pronunciation of "chicken" (*ji*, 鸡) is similar to the word "luck" (*ji*, 吉). Therefore, chickens symbolize fortune and happiness, and are popular subjects for Chinese artists.

Being that roosters are more popular than hens in traditional Chinese ink wash painting, this book will focus on how to paint roosters. In Chinese tradition, a painting of a rooster epitomizes good luck. With the addition of some lychee fruits, the painting symbolizes a wealth of luck and fortune, because the words "lychee" (*li*, 荔) and "fortune" (*li*, 利) are homophones in Chinese. To further exemplify luck, bamboo, plum blossoms, winter jasmine, and peach blossoms can be used to enhance paintings of roosters.

Roosters are easy subjects to start with, but they are hard to finish due to the variety of species and wide range of colors. You will be able to capture the spirit and mannerism of the rooster only when you master its body features and understand its habits. You will be able to paint the rooster with more confidence if you practice sketches of its various body postures, and have mastered the painting techniques. Below is the introduction on how to use the slight freehand style to paint roosters.

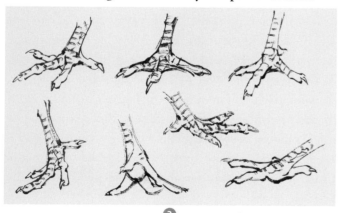

Basic Techniques

The body structure of a rooster is similar to that of a bird. However, the comb and wattles are the two outstanding features of a rooster that need to be highlighted. It is a good idea to use the detailed outline technique or the slight freehand style to paint the comb and wattles. To show the strong male body, you can emphasize its muscles on the breast and legs. Its neck feathers and saddle feathers are formed like needles, which will require detailed work. (Fig. 1)

With four toes on each foot, the rooster's toes are the same as any kind of fowl. Three of its toes point forward and one stands back for balance. A rooster over 4 years old could have an additional toe. The rooster's feet are difficult to draw, so the detailed outline technique or the slight freehand style should be used to paint the feet. Pay attention to the changes in position of the feet. (Fig. 2)

Painting a Rooster in the Slight Freehand Style

In Chinese paintings, instead of portraying a specific type, roosters are often painted in the freehand style. Chinese artists prefer to paint them in four colors: black, white, scarlet, and gamboge. A typical example is to paint the breast, legs, and sickles in dark ink and the neck, back, and saddle feathers in white. The comb is completed in scarlet and the feet in gamboge. This style reflects most of the characteristics of a Chinese painting.

1. Unless you are very familiar with the body structure and posture of roosters, you will need to sketch out the rooster lightly with a pencil, then paint the lines and textures in dark ink before you erase the sketching. Pay special attention to the variations of lines while using the dark ink. Since every artist has his own style, there is no set rule as to where to apply thick or thin lines. However, if there are no variations in the thickness of lines, the painting will not look lively. (Fig. 3)

2. Next, tip a clean brush in the dark ink. Outline the breast and legs by using centered-tip strokes. Then finish painting the breast and legs by using a few side-brushes with dark ink, leaving some highlights in between. (Fig. 4)

3. The ink on the brush will lighten since the dark ink has already been used to paint the breast and legs. The light shade is good for painting the sickles and feet. (Fig. 5)

4. Paint the comb and wattles in scarlet, and finish the feet in gamboge. (Fig. 6)

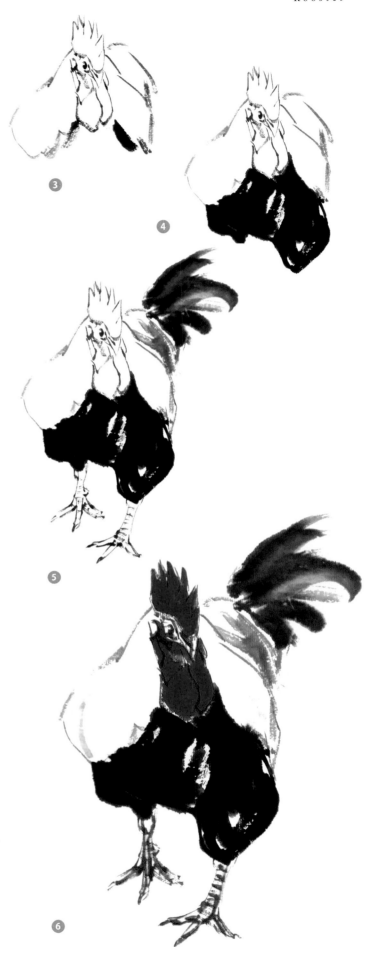

7

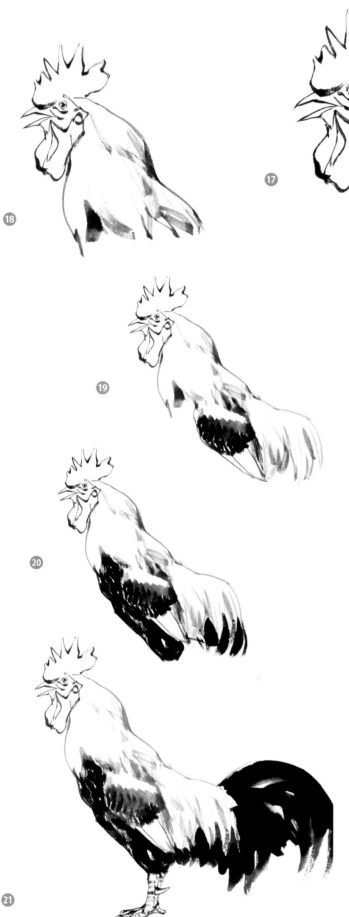

A Showcase

Every artist has his own style, and even with the slight freehand style, everyone is unique. Let's apply all the slight freehand techniques that were introduced above to a new painting.

In Chinese, the pronunciations of "bamboo" (*zhu*, 竹) and "good wish" (*zhu*, 祝) are similar. The combination of a rooster and bamboo in a painting is a popular way for the Chinese people to express their wish for good luck.

1. Paint the head in dark ink and enhance the comb. The lines must show variation of shades and control of thickness. (Figs. 17, 18)

2. Outline the wings, the back, and the saddle feathers in light ink. (Fig. 19)

3. Then paint the breast and legs in shades of dark ink, leaving some highlight in between. (Fig. 20)

4. Tip the clean brush in dark ink to outline the feet, and then paint the sickles with side-brush strokes. (Fig. 21)

5. Use vermilion or scarlet mixed with carmine, to paint the comb. Paint the mouth in gamboge and the feet in indigo. To show a three-dimensional effect, trace the body outline in light burnt sienna. (Fig. 22)

6. Add a big rock under the feet of the rooster by using dark ink. (Fig. 23)

7. Then complete the painting by adding a few bamboo to the background. When a rooster crows, it wakes up thousands of people in the morning, so the painting must reflect this kind of command and power. (Fig. 24)

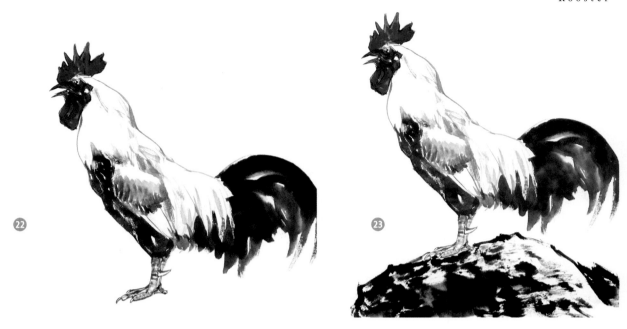

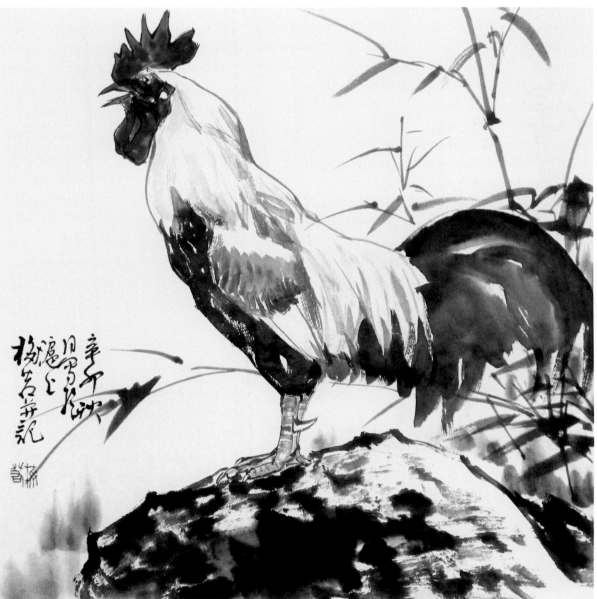

Duck

Ducks are divided into two categories: farm-raised ducks and wild ducks. Farm-raised ducks are one of the most popular types of poultry in China. This chapter will focus on how to paint farm-raised ducks in the slight freehand style.

Farm-raised ducks waddle while walking. They look a little silly, but they are fun to watch. To paint a vivid portrait of a duck, you need to master the techniques to capture its looks and postures.

The feathers and the markings on its body are an important part of the painting. The male ducks usually have multiple colors. If you combine the details from the fine-brush style with the freedom of the freehand style, you will be able to achieve an extraordinary effect of the painting.

In Chinese paintings, ducks are often associated with water. The paintings of ducks usually have a riverbank as a background which reflect the theme of one of the ancient Chinese poems: "Ducks are the first to know when spring comes and water turns warm."

Basic Techniques: Body Structures

In order to paint a vivid portrait of a duck, it is important to paint its head precisely. From the front view and side view, a duck's head looks just like a spoon. From the back view, it looks like the head of a cane. Also, it is important to show the correct position of its eyes in relation to its bill. When you look straightly at the duck's face, its eyes and its bill form an upside down triangle. However, if you look at it from the side or back, its one eye forms a straight line with its bill. (Fig. 1)

You can vary the movement of a duck simply by changing the angle and orientation of its head without changing its body position. The two ducks on the left are in the same body position, but with different head orientations. One is looking straight ahead while the other is looking over its shoulder. The two ducks on the right are also in the same body position, but with different head orientations. One is slightly looking up while the other is slightly looking down. (Fig. 2)

Although the two ducks are in the same position, since one is standing while the other is lying, their stomachs clearly have different shapes. One has its stomach in and the other has its stomach out. Only when you capture these changes in their bodies can you illustrate accurately the movement of ducks in

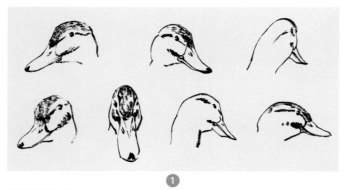

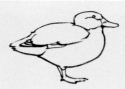
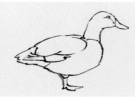
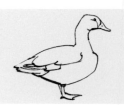

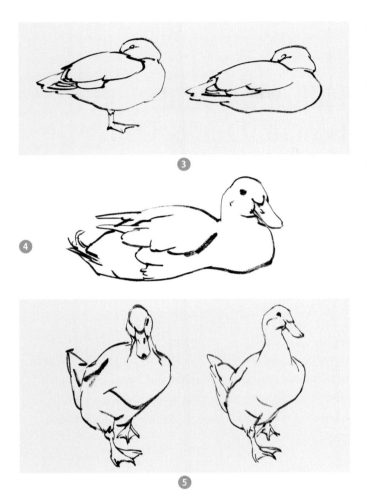

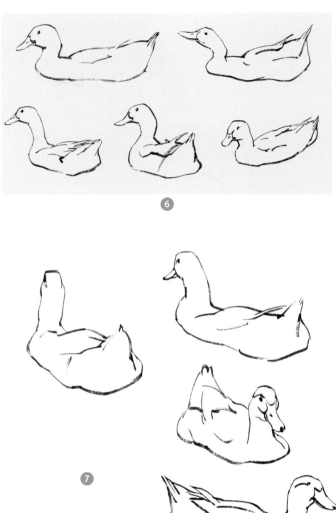

your paintings. (Fig. 3)

A duck's breast can be changed into different shapes while it is in different positions. If a duck floats over the water or lies on the ground, its round breast will be in an arc shape. (Fig. 4)

Basic Techniques: Movement

If you look carefully, you will notice that while walking, the duck's feet positions line up with its body. In this picture, the duck on the left holds his head straight forward while the duck on the right looks sideways. Therefore, you can tell apart by how they walk. The change in the head's angle and orientation is extremely important in painting ducks. (Fig. 5)

When ducks are swimming, their bodies are in a shape that looks like the number "2." If you look carefully at this figure, you will notice that

all the ducks are swimming towards one direction, however, you can create many looks by the different combination of the orientation of their heads and the bills, the angles of their bodies, and the shapes of their tail feathers. Whenever you get a chance, watch closely at the movement and body positions of ducks while they are swimming. This will help you to paint ducks more vividly. (Fig. 6)

You may also create a sense of space for the ducks playing in the water by changing the directions of their swimming. If you only paint the ducks swimming to the left or right, the picture doesn't have a 3D effect. If you include multiple ducks that are swimming to the left or right, backwards or forwards, you will achieve a 3D effect and also leave very little space empty in your painting. (Fig. 7)

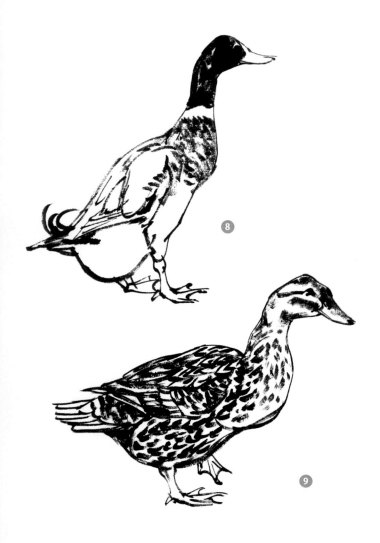

Painting a Male and a Female Ducks Using the Outline Sketching Technique

Any beginner can first sketch out the ducks' bodies with a pencil, and then use a brush to outline their positions. Complete the painting of the ducks by adding colors.

It takes a lot of practice to master the brush techniques of Chinese paintings. Once you master the techniques, you will be able to paint the textures of different objects with different brush strokes and shades of ink. We are going to introduce a simple outline sketching technique here which is easy for beginners to master.

1. First think how to position the ducks, and then sketch out their bodies on the paper. After that, outline the whole body of the female duck in dark ink. (Fig. 10)

2. Outline the head and the back of the male duck in dark ink. The curled feathers at the end of its tail need to be highlighted with extremely dark ink. Then outline the stomachs in light ink. Make sure to show the changes in the shapes of their stomachs and breasts to reflect their movement while swimming. (Fig. 11)

3. Mix burnt sienna with dark ink to paint the markings on the head of the female duck with light strokes from top to bottom. (Fig. 12)

4. Tip your brush with dark ink to paint the markings on the feathers on the back of the female duck using side-brush strokes from left to right. (Fig. 13)

5. Dot the markings on the coverts around the triangle area of her tail in dark ink from top to bottom. Make sure the top part is more thickly dotted than the bottom part. (Fig. 14)

6. Paint the head and upper part of the neck of the

Basic Techniques: Male and Female Ducks

A male duck has a big head, a round body, and a pointy tail with some curled feathers at the end. His feathers have bright colors, most likely a combination of burnt sienna, blue and green with a few markings on them. (Fig. 8)

A female duck has a small head and a thin body. She doesn't have any curled feathers at the end of her tail, but her tail feathers are usually spread apart. The color of her feathers is usually dull, but of a more natural tone with more markings on them. Some female ducks have pure brown feathers with a few grey markings and others have black and white markings only. (Fig. 9)

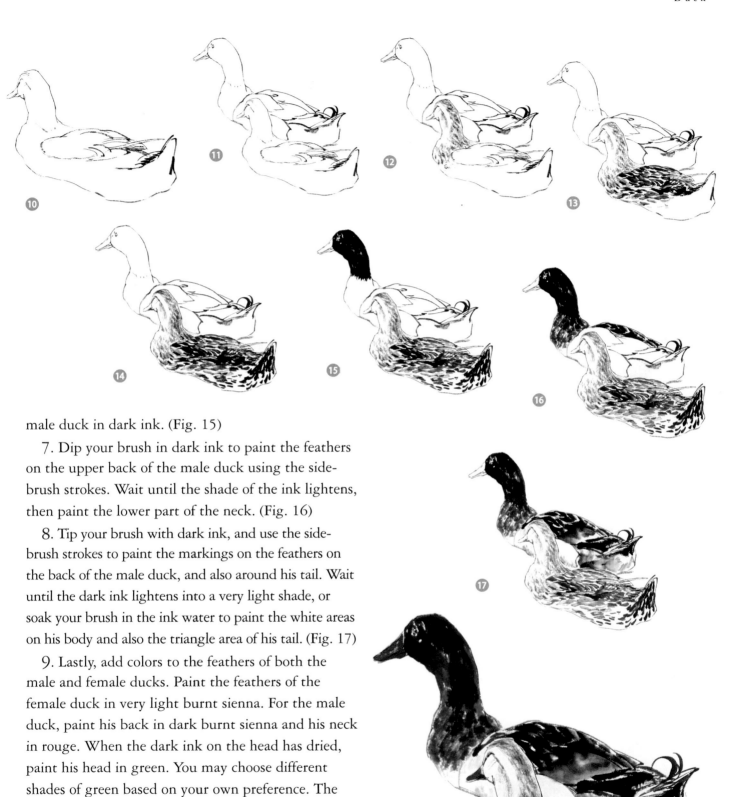

male duck in dark ink. (Fig. 15)

7. Dip your brush in dark ink to paint the feathers on the upper back of the male duck using the side-brush strokes. Wait until the shade of the ink lightens, then paint the lower part of the neck. (Fig. 16)

8. Tip your brush with dark ink, and use the side-brush strokes to paint the markings on the feathers on the back of the male duck, and also around his tail. Wait until the dark ink lightens into a very light shade, or soak your brush in the ink water to paint the white areas on his body and also the triangle area of his tail. (Fig. 17)

9. Lastly, add colors to the feathers of both the male and female ducks. Paint the feathers of the female duck in very light burnt sienna. For the male duck, paint his back in dark burnt sienna and his neck in rouge. When the dark ink on the head has dried, paint his head in green. You may choose different shades of green based on your own preference. The green varies from "Number 1 green" to "Number 2 green" to "Number 3 green." The "Number 3 green" is the lightest shade of all three. In the containers of the Chinese painting pigments, you may only find the "Number 3 green." Finally, paint their bills in gamboge. (Fig. 18)

1 5

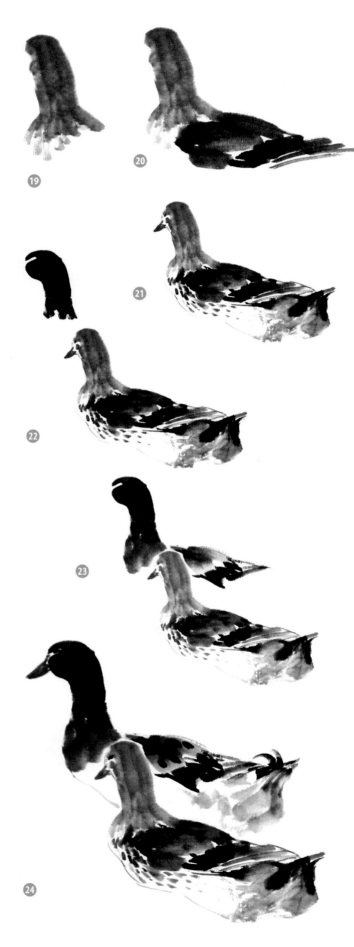

Painting a Male and a Female Ducks Using Slight Freehand Style

Experienced artists can paint the ducks with their brushes without using the outline sketching technique. It takes a lot of practice to master this technique. Beginners usually find that the dark ink disappears in the rice paper as soon as it touches the paper, but this problem can be solved when you become more skilled.

1. First, dip your brush in burnt sienna and then in ink. Paint the head of the female duck from the top of the head down to the neck. It doesn't matter if you use several strokes. (Fig. 19)

2. Dip your brush in dark ink to paint the back and wings of the female duck. Since you are using the slight freehand style, you don't need to worry about painting the details of the wings, but you need to use quick strokes to illustrate the features of her flight feathers. (Fig. 20)

3. Paint the coverts under her tail and the triangle area of her tail in light ink. Paint her tail area in light burnt sienna. Add a certain amount of markings on the feathers under her stomach. Finally, paint her bill in gamboge. (Fig. 21)

4. Paint the male duck after completing the female duck. First, paint his head in dark ink to position his body. (Fig. 22)

5. Paint his neck in burnt sienna. Dip your brush in dark ink to paint the feathers on his lower back. Wait until the ink lightens, then finish painting his back. (Fig. 23)

6. Paint the tail area of the male duck in light ink. Make sure the feathers at the end of the tail are curled and are painted in dark ink. Dot his eyes in dark ink. Outline his stomach in light ink and color his bill in gamboge. (Fig. 24)

16

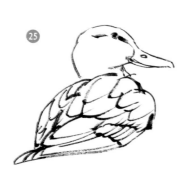

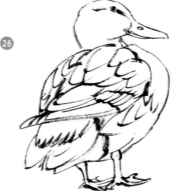

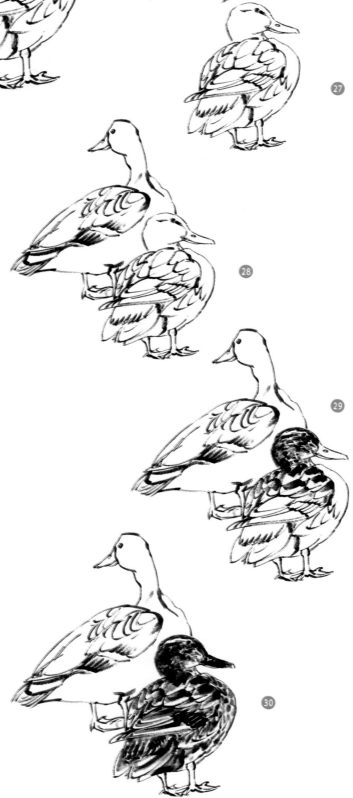

A Showcase

Now we will create a painting with two ducks by the river using the painting techniques introduced above, and in combination with the techniques described in the Basic Techniques section regarding the effect of the change of the angles and orientation of the head on the body positions. The two ducks look as if they are resting or trying to figure out what's in the distance. In Chinese paintings, it is a tradition not to convey the theme directly, but to leave room for the imagination.

1. Before painting, plan out the posture of the male and female ducks and their positions. The male duck turned his head at a 90-degree angle against his body, looking over his shoulder. The female duck was positioned sideways. First, sketch out their bodies and then outline the feathers on the head and the back of the female duck with fine lines in dark ink. (Fig. 25)

2. Next, paint her stomach and her two feet. (Fig. 26)

3. After finishing painting the female duck, paint the male duck. First, set the position of his body by outlining his head at a 90-degree angle with its neck. Then edge out his feathers on his upper wings. (Fig. 27)

4. Dip your brush in dark ink to paint his body, his coverts underneath his tail, his flight feathers, and his feet. (Fig. 28)

5. Mix burnt sienna with ink to paint the feathers on the head of the female duck. Then paint the markings on the feathers of her back using the "dotting" technique. (Fig. 29)

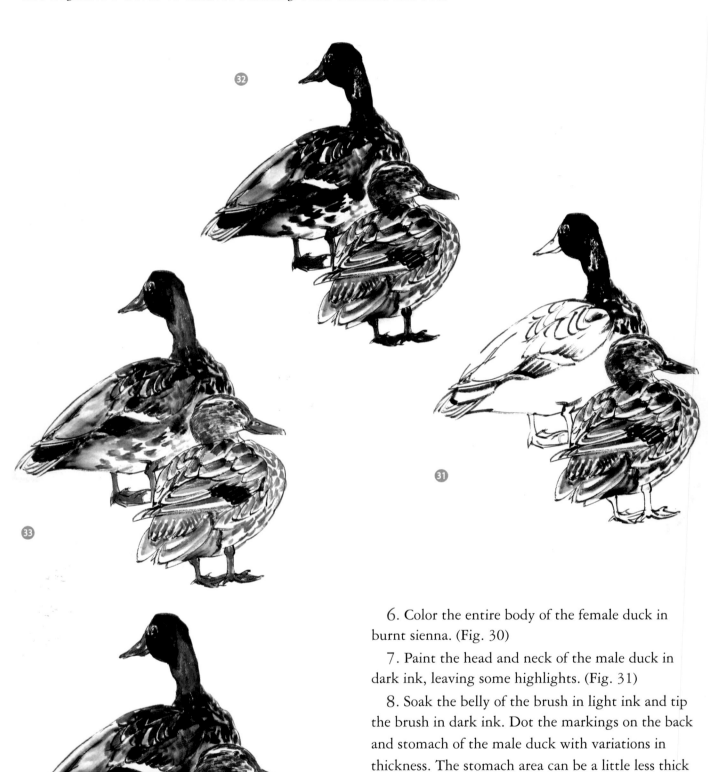

6. Color the entire body of the female duck in burnt sienna. (Fig. 30)

7. Paint the head and neck of the male duck in dark ink, leaving some highlights. (Fig. 31)

8. Soak the belly of the brush in light ink and tip the brush in dark ink. Dot the markings on the back and stomach of the male duck with variations in thickness. The stomach area can be a little less thick with the markings. (Fig. 32)

9. Wait until the ink dries, and then paint the head of the male duck in Number 3 green or blue. Also, apply blue to the secondary flight feathers of both the male and female ducks. (Fig. 33)

10. Paint their bills in gamboge and their feet in vermilion. (Fig. 34)

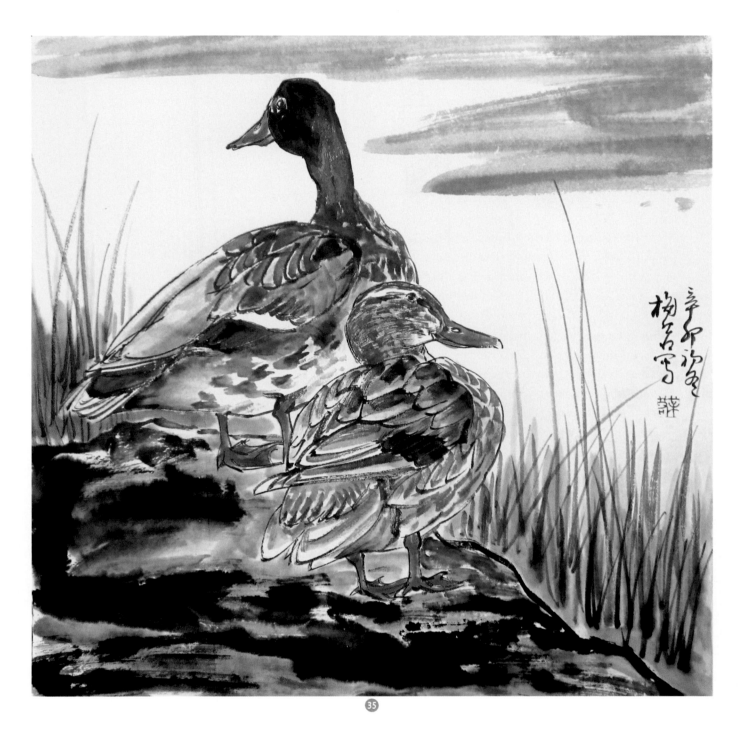

(35)

11. Tip your brush in dark ink, leaving some water in the base of the brush. Add some rocks beneath the ducks' feet and some grass on the bank. The grass needs to be thin and long. Soak your brush in light ink to paint the winding riverbank using the side-brush strokes. Sign the painting with your name after you complete the background. Thus, a painting with two ducks by the river is completed. (Fig. 35)

Rabbit

The Rabbit ranks fourth in the Chinese Zodiac. It is gentle and lovely, as well as smart and alert. It has become a popular subject for many artists. Its fluffy hair, unique red eyes, and long ears make it endearing to many people. The Chinese paintings of rabbits usually show two rabbits together to express two good wishes—"good luck and good fortune."

The head of a rabbit resembles the features of the head of a rat. It has long ears, with its upper lip divided into 2 halves under the nose, typically called "hare-lip." Its tail is short and points upwards. Its well developed back legs are longer than the front legs. They are good at hopping and running. Its hair color varies from white to grey to black. Some even have markings on the hair. Only after you master the special features of its body will you be able to paint a fluffy and round rabbit.

This chapter will show how to paint rabbits in the great or slight freehand style.

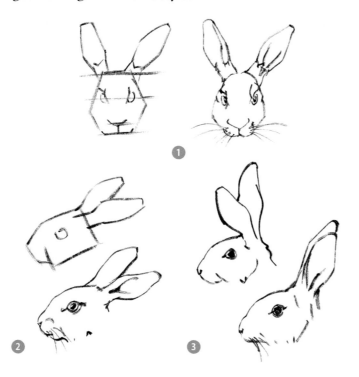

Basic Techniques

You need to familiarize yourself with the head structure of a rabbit before you begin to paint. First, draw a hexagon with a pencil, and then use "four horizontal lines" to position its forehead, eyes, nose, and mouth in the hexagon. It is very important to control the space between the lines. The space between the eyes and nose is the widest, followed by the space between the forehead and eyes. The space between the nose and the mouth is the narrowest. You also need to determine the ratio of the length of the face to the length of the ears in your sketch. The length of its ear equals three times the width of its ear. Trace the outline on the geometric diagram with a brush so that its face can be shown clearly. (Fig. 1)

From a side view, the head of a rabbit consists of three parts: a quadrilateral where its nose and its mouth reside, a rectangle where the eyes sit in the middle, and two irregular hexagons representing two ears. Look closely at the geometric diagram on the above, and try to turn it into the drawing below. If you compare this drawing with Fig. 1, you will notice that if you look from the side view, the rabbit's eyes are an oval shape. However, if you look from the front, its eyes are actually round. If you look from different angles, the quadrilateral can be in different forms as well. Sometimes it looks like a square and at other times it looks like a rectangle. (Fig. 2)

Both of these pictures show the side view of a rabbit's head. However, since the shapes of their ears are different, they give two different looks. The picture

above shows ears of the rabbit crossed with each other. The picture below shows the ears of the rabbit standing up and overlapping one another. The variation of the ear position can enhance the richness of the painting and the vividness of the portrait, therefore better conveying the theme of the painting. (Fig. 3)

The ears of the rabbits can form many positions. Some split apart to the side, some overlap, and some split across front and back. You will be able to create the many different looks of rabbits if you master the techniques in painting their ears in different positions. If you compare the heads of the rabbits above with the ones below, you will notice that even with the same ear positions, if an artist looks at them from a different angle, the angle and orientation of the ears will change, too. (Fig. 4)

Most artists like to paint two rabbits instead of one. When you paint two rabbits in one painting, you need to organize their positions and body orientations. Even if the two rabbits are facing the same direction, you still need to pay attention to the changes in their head angles as well as their body positions. (Fig. 5)

Rabbits usually have very long hair. It is important to express its softness in your painting. Below, we will introduce four methods on hair painting techniques. (Fig. 6)

Method ①: Soak your brush in ink, leaving some water at the base of your brush. Paint the hair with side-brush strokes. Let the ink gradually soak into the rice paper. This method can be used to paint the grey markings on the rabbit's body or to show the texture of its hair.

Method ②: After you complete Method ①, tip your brush with dark ink to make a few dots on the patches of the light ink. Let the dark dots absorb into the rice paper. This method can be used to show the dark markings on the body.

Method ③: Dip your brush in dark ink and paint the hair of the rabbit in two side-brush strokes: one stroke to show an upward arc and the other stroke to

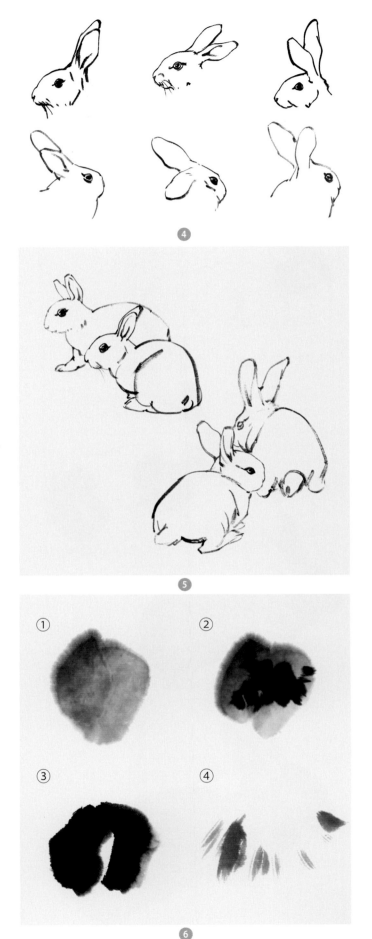

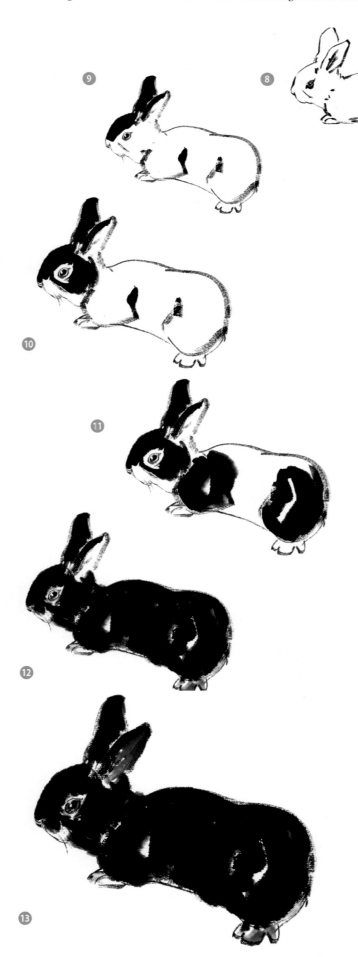

show a downward arc so that a circle or an oval can be formed. This method can often be used to show the dark hair of a rabbit.

Method ④: Press your brush down flat. Use the centered-tip strokes radiating down to paint the short hair of a rabbit. Make sure you are using very light strokes. This method is used to show the short stubby hair on its body.

Painting a Black Rabbit in Slight Freehand Style

This is a black rabbit with simple movement. You will be able to find out the body structure of a rabbit through this step-by-step process.

1. Outline the look of the rabbit with a pencil. You may use an oval to represent the head and use three circles to represent its front, middle, and back part of the body, respectively. Make sure the three circles are overlapping to some extent so its body will look like a raised arc. Finally add the ears, feet, and the short tail. (Fig. 7)

2. Dip your brush in dark ink, and then trace the outline of the body in the sketch. Its body then becomes a long oval shape with a concaved stomach. Its back and bottom are slightly arched. (Fig. 8)

3. Use Method ③ introduced above to paint its hair. Dip your brush in dark ink to paint the back side of its ears with side-brush strokes. Paint its forehead in dark ink also. Then use the tip of your brush to add two or three whiskers on the side of its mouth. (Fig. 9)

4. Use the same method to paint its face in dark ink. (Fig. 10)

5. Paint the front legs and the bottom in dark ink by following Method ③ of the hair painting techniques.

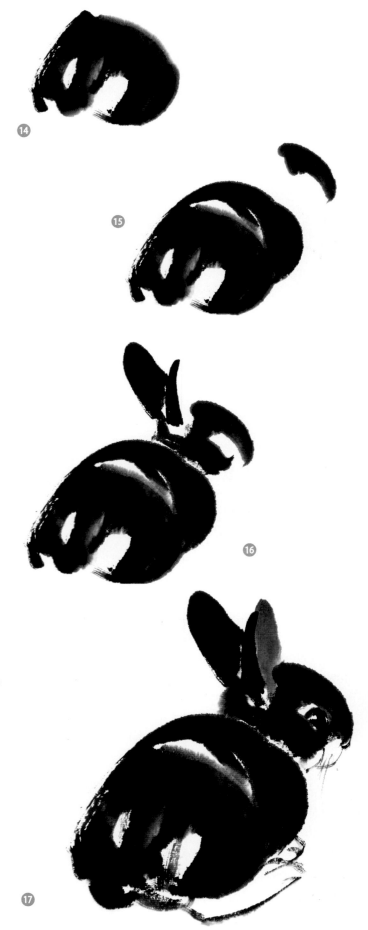

Make sure to leave some highlights. (Fig. 11)

6. Then paint the middle section of the body in dark ink as well. Wait until the dark ink lightens, then paint its feet in light ink. (Fig. 12)

7. Paint the inside of its ears and its eyes in vermilion or burnt sienna. (Fig. 13)

Painting a Black Rabbit in Great Freehand Style

Compared to the slight freehand style, the great freehand style offers more freedom. Next, we will paint a black rabbit looking over to his right side from a new angle.

1. Think of the rabbit's body position and its head orientation. Because we are using the great freehand style to paint the rabbit, you can apply Method ③ of the hair painting techniques to paint its bottom without outlining it, leaving some highlights on the back legs. (Fig. 14)

2. Because the rabbit's back is towards the viewer, the middle section of its body is in a fairly high arc which shows the roundness of its body. Paint the fullness of the arc with even shades of ink by following the same techniques as introduced above. Leave some highlights on the back and the bottom. Also leave some space on the front part of the body. Paint the forehead in one stroke. (Fig. 15)

3. Use one stroke to outline the face on the oval-shaped head, and then use another stroke to connect its face with the forehead, leaving some room on the right side of the face for the eyes. Paint the bottom of its ears on the left side of the head. Due to the viewing angle, one of the two ears should be painted in full size while the other one should be slightly thin in shape. (Fig. 16)

4. Dip your brush in dark ink. Paint the eyes on the head. Wait until the dark ink lightens, outline the shape of its mouth, and then add three whiskers. Paint two feet under its body. Finally paint its ears and eyes in carmine. (Fig. 17)

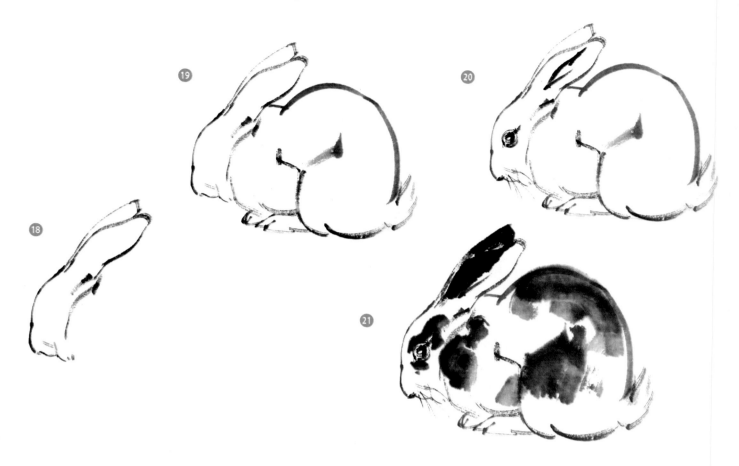

Painting a Rabbit with Markings in the Slight Freehand Style

The hair color of rabbits varies from white to black, and some have markings. It is very common to use the outline technique to paint the white rabbit. It is also common to use only dark ink to paint the black rabbit. However, to paint a rabbit with markings, you need to combine these two techniques to show the richness in ink and variations in body movement. The rabbits painted with the combination of these two techniques will have more of the characteristics of Chinese paintings.

1. Outline the head and its two ears with dark ink. From the side view, the two ears are almost overlapping. If you are just a beginner, sketch it out with a pencil first by following the method introduced in the section on page 22. (Fig. 18)

2. Outline the body and tail in dark ink, making

the lines of the front legs meet with the lines of the back legs, and then draw two feet. In this painting, the rabbit is curling up tightly. Therefore, while drawing the three circles to make the body, make the middle circle above the other two circles. The other two circles lay side by side almost touching each other. This shows a vivid image of a rabbit curled up tightly with its front legs touching its back legs. (Fig. 19)

3. Tip the brush with dark ink to outline the eyes, the whiskers, as well as the wrinkles on the ears. (Fig. 20)

4. Next, follow Method ① of the hair painting techniques to paint the front side of the ears, area around the eyes, the front part of the body, the back, and the black markings on its bottom in light ink. The front side of its ears is dark in color, therefore they should be painted in dark ink. (Fig. 21)

5. Follow Method ② of the hair painting techniques to add a few dark black dots on the light-shaded markings. Let the rice paper absorb the ink to achieve the effect of spreading the ink. Lightly outline its body in ink water or light burnt sienna. Then

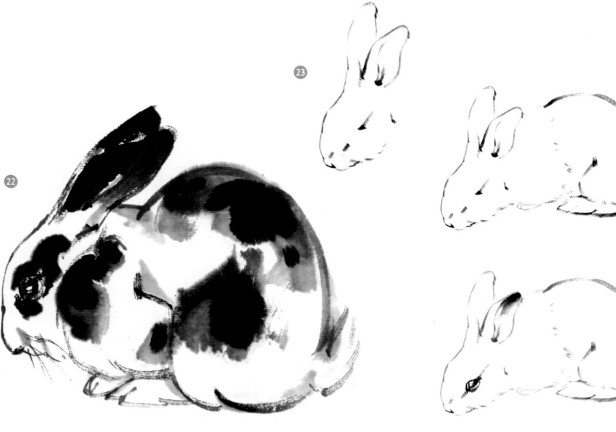

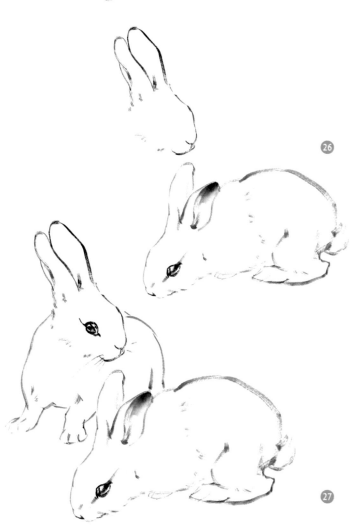

paint the ears and eyes in orange red. The inner part of the ears is full of blood vessels, therefore it should be painted in carmine. (Fig. 22)

A Showcase

This painting is called *A Pair of Rabbits*. We will use a combination of all the methods and techniques introduced above to create a complete art work.

1. Lay out the head orientations and body positions of these two rabbits in the painting, and then outline the side view of the head of the front rabbit in dark ink. (Fig. 23)

2. Outline the body shape in dark ink, making the bottom slightly uplift. (Fig. 24)

3. Paint the eyes in dark ink and finish the ears with the rest of the dark ink. (Fig. 25)

4. Then start to paint the rabbit at the back of the picture. First paint its head so that you can accurately position its body. Make sure it is not too high up or too

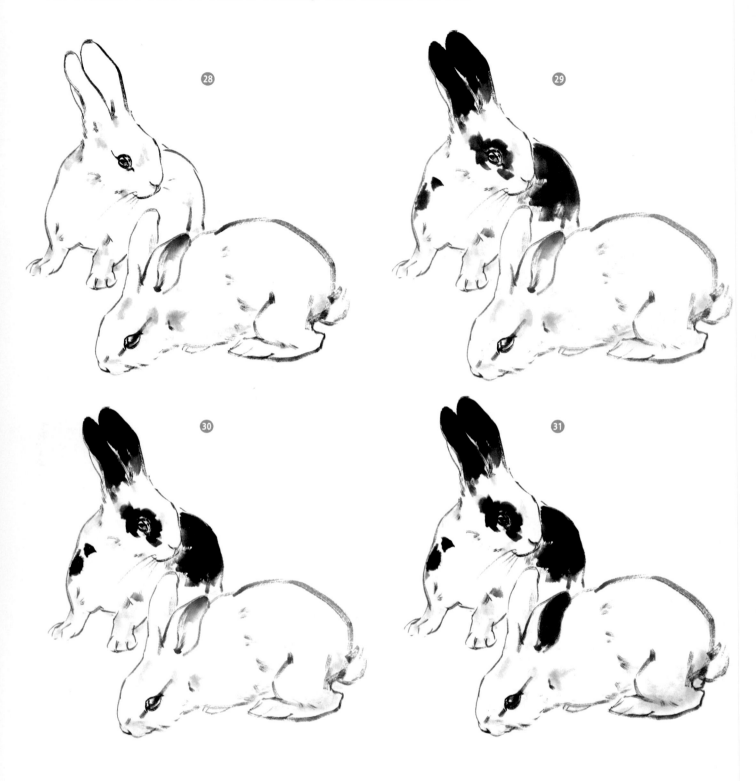

down low in the picture. The head turns at a 45 degree angle. This makes the rabbit look livelier. (Fig. 26)

5. Outline the body next. Make sure that the front rabbit covers the back feet of the rear rabbit, but the front feet of the rear rabbit are clearly outlined. (Fig. 27)

6. Paint the short stubby hair on its head and body by following Method ④ of the hair painting techniques. Use light strokes and light ink. (Fig. 28)

7. Add the markings on its bottom, ears, and front legs in light ink by following Method ② of the hair

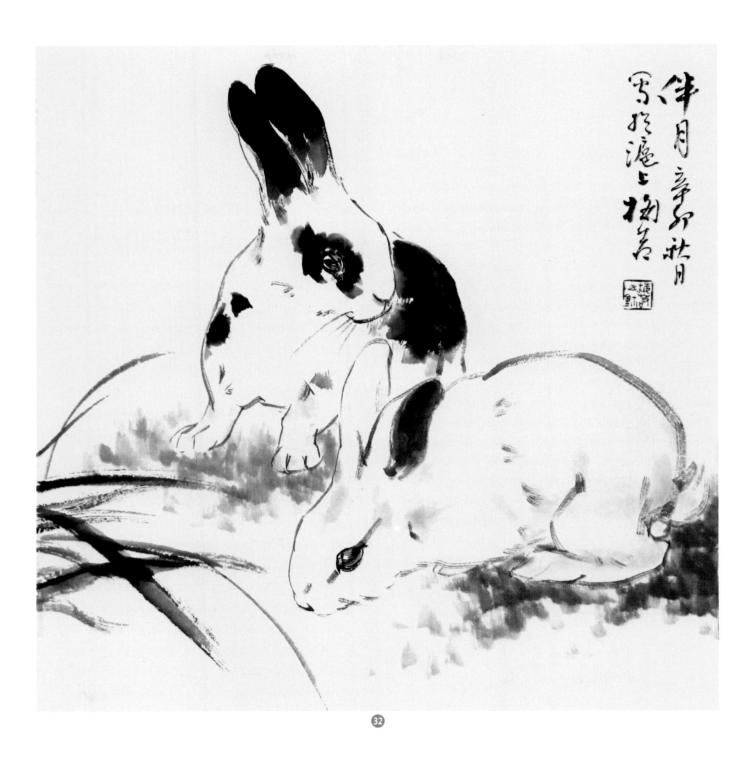

③②

painting techniques. (Fig. 29)

8. Then dot the markings in dark ink. The painting of a white rabbit in the front and a rabbit with markings at the back is now complete. (Fig. 30)

9. Paint their eyes in carmine as well as the ears of the front rabbit. (Fig. 31)

10. Add some light green grass under the feet of the rabbits. Add some dark green leaves to the side of the painting. Sign the painting. This completes the painting of *A Pair of Rabbits*. (Fig. 32)

2 7

Cat

Cats—possessing very expressive eyes and mouths—make very adorable pets. Their changing postures, whether active, still, relax, or pensive, give a good indication of their moods. To accurately paint cats, you need to observe them closely, even play with them, in order to capture their unique characteristics.

This chapter will focus on using the freehand style to paint cats, a popular subject in Chinese painting. The freehand style was very popular to use for painting animals in the Ming dynasty (1368 – 1644), and it is still a popular style for most of the artists of today. The freehand style expresses the richness of the painting through simple brush strokes. To leave room for the imagination, artists manipulate the strokes in an abbreviated manner without emphasizing on the details. However, the spirit and characteristic of the subjects can be highlighted. The painting can also be enhanced by adding objects to the background that reflect the animal's habits and living environment, or you can simply add some green grass without adding any additional objects.

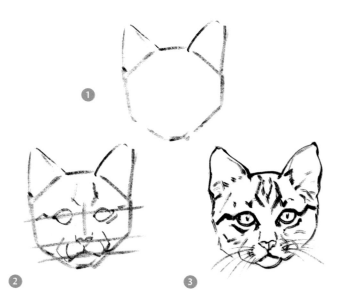

Basic Techniques: Outlines and Postures

The cat's body is divided into five sections: head, neck, body trunk, limbs, and the tail. Before starting, you need to be very familiar with the basic features of its head, and the changes in its postures.

The cat's face is form by an octagonal shape with its two wide ears sticking outside the octagon. (Fig. 1)

Use three horizontal lines and one vertical line to position the five facial parts. The eyes, nose, and mouth line up with the top, middle, and bottom lines, respectively. The position of the nose is on the vertical line, which forms right angles with the mouth line. Pay attention to the space between the lines. Different breeds have different spacing and proportions of their facial parts. (Fig. 2)

The easiest way to accurately outline the face is to sketch it out first with a pencil, and then paint it over in dark ink with a brush. (Fig. 3)

A slight change in the space among the three horizontal lines and one vertical line, or a change in the curves of the lines, can easily alter the angle of the cat's head and posture. These postures include looking straight ahead, looking sideways, looking up, looking down, etc. (Fig. 4)

The shape of a cat's nose looks like two triangles connected side by side. Two of the three sides are slightly curved. The outer line is concaved. (Fig. 5)

The cat's whiskers cannot be painted with the same thickness. Paint the whiskers near its mouth in thick lines and the ones away from its mouth in curved thin

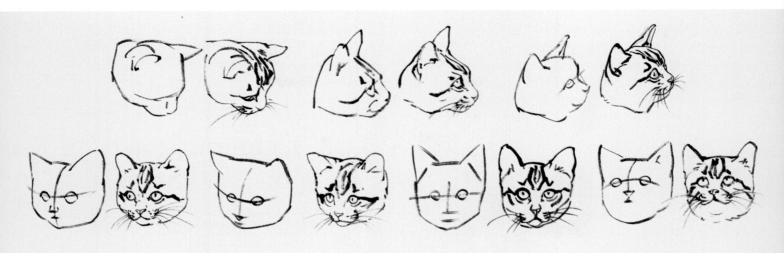

④

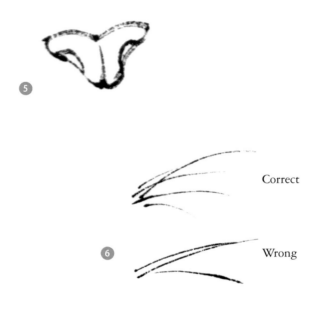

⑤

⑥

Correct

Wrong

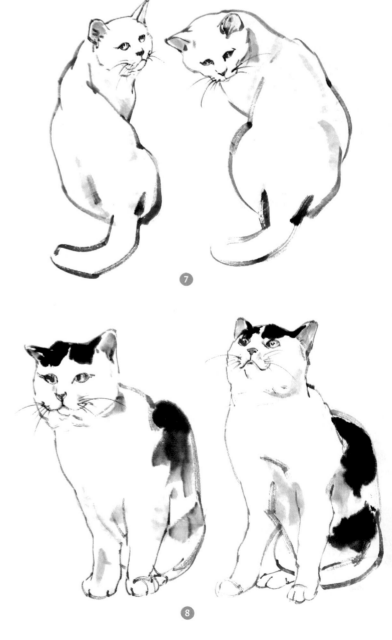

⑦

lines. Start with the thick lines using heavy strokes in dark ink, and then lift the brush gradually to lighten the ink and to thin the lines. (Fig. 6)

After mastering the techniques in painting the head, you need to combine the head with the body to show various postures. In this painting, you see two cats with similar body postures, but with different head angles, which result in two different expressions. (Fig. 7)

This painting shows two cats with similar fur coats and body builds, but their heads face separate directions. One is looking straight ahead and the other is looking up, resulting in two different postures. (Fig. 8)

⑧

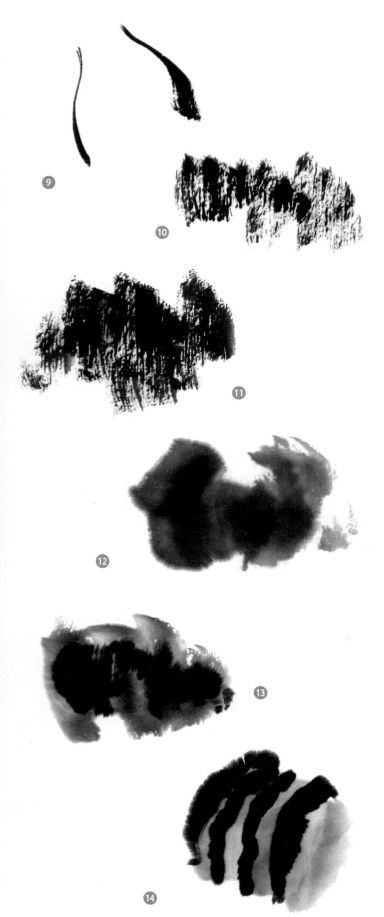

Basic Techniques: Fur, Spots, and Stripes

Different breeds have different types of fur, spots, or stripe patterns that require different painting techniques. We will introduce six of them here.

Technique 1: Use a brush to paint the stripes. Make sure the stripes are curved properly, and show variations in the shades of ink and thickness of the lines. This technique is often used to show the various muscle tones on a cat's body. (Fig. 9)

Technique 2: Tip the thin brush lightly in the ink, keeping it a little moist. Make the hair on the tip of brush open loosely. Paint it from top to bottom with one quick stroke. This technique is often used to depict short fur. (Fig. 10)

Technique 3: Use Technique 2 with a thick brush instead of a thin brush to form color patches. This technique is often used to depict long fur. (Fig. 11)

Technique 4: Tip the brush with ink, keeping some water in the base of the brush. Use side-strokes to form several small color patches which together will form a bigger patch. This technique is often used to paint the color patches on a cat's body. (Fig. 12)

Technique 5: After applying Technique 4, and before the light ink on the patches dries completely, brush dark ink onto it using Technique 2 or 3. This technique is often used to paint the dark hair on the light color patches. (Fig. 13)

Technique 6: Use Technique 4 to paint the color patches in a very light shade of ink. Before the light ink dries completely, paint the stripes in dark ink using Technique 1. The shades of the stripes will be shown naturally when the ink is absorbed and spread over the rice paper. This technique is often used to paint cats with stripes. (Fig. 14)

Basic Techniques: Adding Color

Now that you have mastered the techniques in painting a cat's coat, we will introduce two methods of adding color to the coat using techniques such as dry brushing and dying with ink. The difference between the methods is in the order of applying the two techniques. Dry brushing means to hold your brush in a slanted or horizontal position. Add the color or ink to the paper with side-brush strokes, and then brush it in evenly with the dry brush in small and quick strokes so that no full brush strokes are shown. You may choose either method based on your own preference and the features of a cat's coat.

Method 1 (Fig. 15)

Step ①: Sketch out the cat's head in pencil and then use a slightly wet brush to outline the head in dark ink.

Step ②: Use Techniques 2 or 3 for painting the cat's fur to brush ink all over the areas above the mouth line by line.

Step ③: Dye it with light ink.

Step ④: For any cat with color patterns, dye it with appropriate colors.

Step ⑤: Before the ink or color dries completely, following Technique 6, dip the brush in dark ink to finish painting the stripes. The stripes will be shown naturally when the ink is absorbed and spread over the rice paper. Pay attention to the differences in the lengths and curves of the stripes.

Method 2 (Fig. 16)

Step ①: Sketch out the cat's head in pencil and then use a slightly wet brush to outline the head in dark ink.

Step ②: After outlining the head, dye it with light ink or other colors, and then brush it with a dry brush. Before the color dries completely, paint the stripes in dark ink. After the ink is absorbed and spread over the rice paper, it will create a hairy texture.

Step ③: Paint the eyes in gamboge, the nose in light carmine or vermilion. Paint the whisker in heavy white if the background is colored. Paint the whisker in dark ink if the background is white.

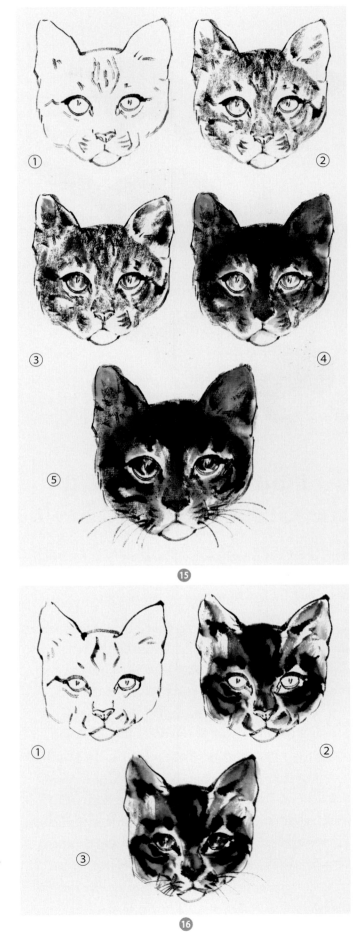

31

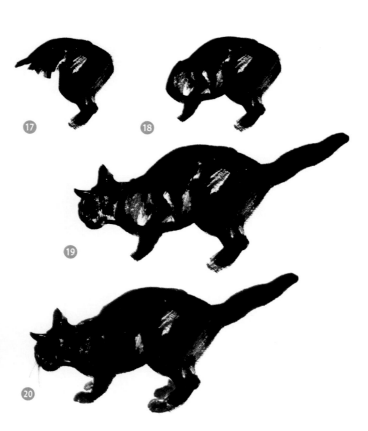

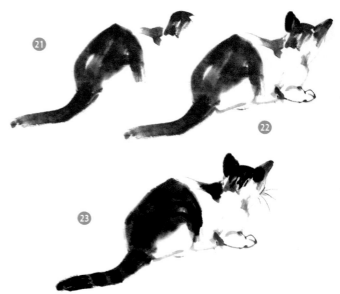

To Paint a Black Cat in the Great Freehand Style

This black cat is tiptoeing about searching for prey. It has a strong body and a straight and thick tail necessary for catching mice in the house.

1. First, outline the cat in pencil by dividing it into three sections; the head, the body, and the tail. Then dip the brush in dark ink to paint the lower part of the body, leaving some parts white. (Fig. 17)

2. Continue brushing with dark ink to finish painting the front part of the body, leaving some white parts to show the effect of highlights. (Fig. 18)

3. Use dark ink to paint the head and the upward tail. This cat has a straight and powerful thick tail. His back legs are slightly bent and the front legs are straight. Pay attention to the position of the ears and the space between the two ears while painting the head. (Fig. 19)

4. Complete the painting with some whiskers on the head. (Fig. 20)

To Paint a Kitten in the Great Freehand Style

In this painting, the cat has its back to the painter, and looks as if it is ready to pounce. Although its tail is lying on the floor, you can feel a sense of movement. What is it looking at? Chinese paintings usually reflect the spirit of the subjects. Although the cat's face cannot be seen in the painting, it fuels the imagination of the viewer, which is the essence of Chinese paintings.

1. Outline the cat's body in pencil, and then dip the brush in burnt sienna. Keep some water in the base of the brush. Paint the tail from the base, and then finish painting the body, leaving some white parts as highlights. To finish, dye the head in color accordingly. (Fig. 21)

2. Use light ink to paint the two ears. Wait for the ink to light up, and then outline the belly and feet. At the joints of the limbs and body, thicken the lines with light ink to show the characteristics of the body structure. (Fig. 22)

3. Before the burnt sienna and light ink dries, use dark ink to paint the spots and stripes on the body following Technique 6 on page 30. Then dip the brush in light ink to paint the whiskers. Make sure some whiskers show a variation of thick and thin. (Fig. 23)

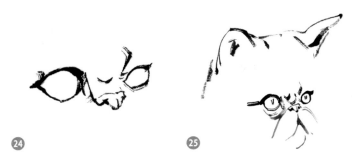

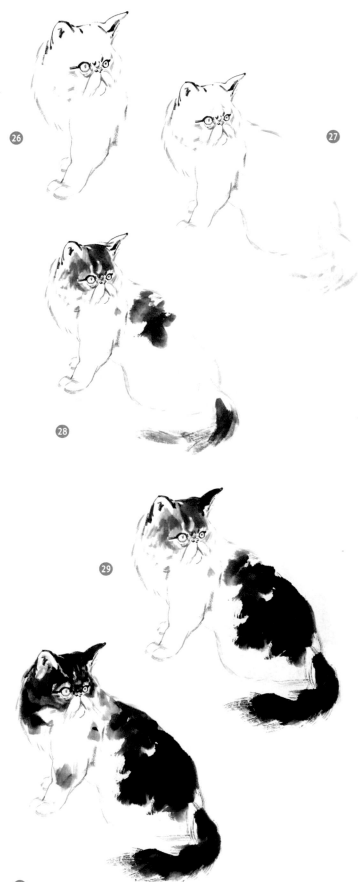

A Showcase

This painting portrays a Garfield cat with a flat face and long hair. Chinese artists usually avoid painting animals in standstill mode. A standstill creature looks like a mounted stuffed animal. However, in this painting, the cat looks lively with its head looking over its shoulder.

1. Sketch out the face with a pencil using the "three horizontal lines and one vertical line" technique on page 28. Pay attention to the features of the flat face. The space between the eyes and the tip of the nose is short and the space between the eyes and forehead is wide. (Fig. 24)

2. Outline the eyes, nose, ears, and hair around the mouth in dark ink. (Fig. 25)

3. Outline the front part of the body, including the two front feet, in light ink. (Fig. 26)

4. Outline the back part of the body and the tail curled in a "C" position in light ink. This creates a posture of the cat looking over its shoulder. (Fig. 27)

5. Dip the brush in burnt sienna. Leave some water in the base of the brush. Use the side-brush strokes to paint the color patches on the head, the upper back, and the tail to show the hair. (Fig. 28)

6. Dip the brush in dark ink. Leave a little water in the base of the brush. Use the side-brush strokes to paint the dark patches on the lower part of the body and the tail to show the dark hair. (Fig. 29)

7. Before the burnt sienna dries completely, add some black stripes onto the burnt sienna patches by letting the ink absorb into the rice paper. (Fig. 30)

33

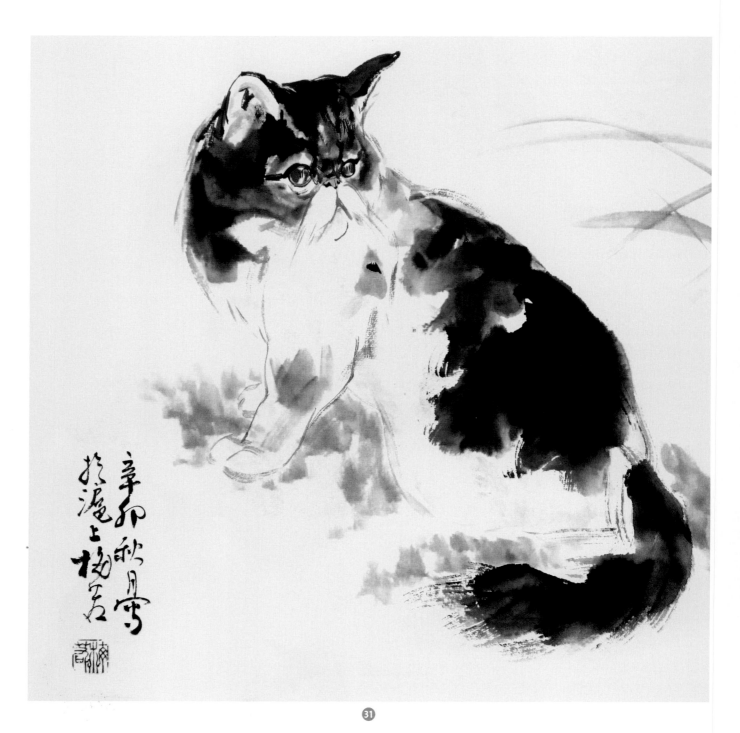

8. Complete the painting by adding some green grass and some weaving branches in light ink to the background. (Fig. 31)

Dog

The dog occupies the 11th position in the Chinese Zodiac cycle. According to the ancient Chinese theory of yin and yang, the characteristics of the Dog Sign are tempered by one of the Five Chinese Elements, Metal, which represents fortune and wealth. Dogs were the earliest domesticated pets in human history. The Chinese proverb says that "…dogs guard the night, chickens start the morning…" and "…horses are loyal, sheep are obedient and dogs are trustworthy." Dogs are lovely and playful animals that often become deeply involved in people's lives, and make loyal friends and companions to them. People are so appreciative of dogs that they hold high standards for vivid portrayals of them.

Dogs are one of the hardest animals to draw. It is said that the most difficult human feature to draw is the hand; the most difficult animal to draw is the dog. The reasons being that dogs come in a wide variety of breeds with very complicated body structures and are very active, therefore making it very difficult to accurately capture their features. For a beginner, the key to success for a drawing is to make it true to life. The feel of the texture of the dog's hair is extremely important in painting a dog; therefore it needs a lot of detailed work.

Basic Techniques

Hair is a focal point of a painting of a dog. Some breeds have very long, yet very soft hair. The *simao* (feather-edging) stroke can be used to vividly enhance its characteristics. Here are the steps: First, press the brush open in the palette, and then depending on the texture of the hair, you may either curve the strokes in an s-shape or paint it in a straight line. Since the Pekingese has very curly hair, it is appropriate to use the s-shape strokes; however, the Pomeranian has fairly straight hair, therefore, it is appropriate to paint it in straight lines. (Fig. 1)

The dog's head is one of the key elements of a successful painting of a dog. Since dogs come in a wide variety of breeds, let's take the Pekingese as an example. Observe the dog's head closely in regards to the distance between the eyes, nose and mouth, and the proportion of each part. Then sketch out the dog's head in three dimensions. (Fig. 2)

Use Chinese painting linear techniques and texture stroke method to complete the painting of the three dimensional sketch of the head. The shades of ink play an important part in Chinese painting. There are five different shades of ink, which are dark, light, dry brush, wet brush, and charred (burnt). The variation of the colors can be presented through the variation of the shades. A dark ink is usually applied over a proceeding application of a light ink. The tip of the brush carries dark ink and the base of the brush contains clear water. At the first stroke, the dark ink gradually gets absorbed into the special rice paper

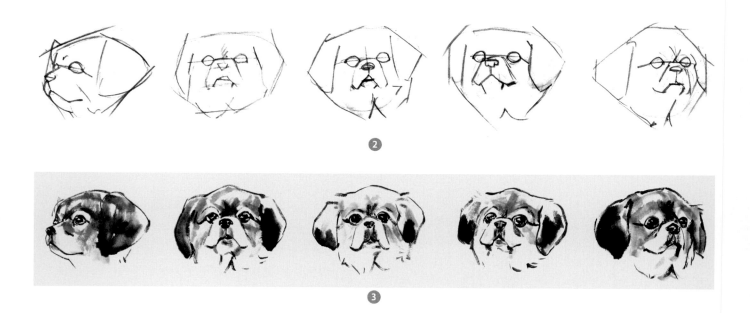

②

③

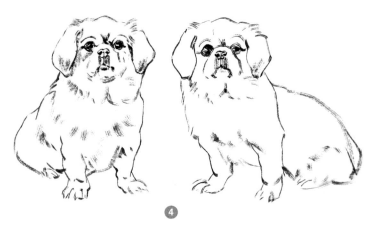

④

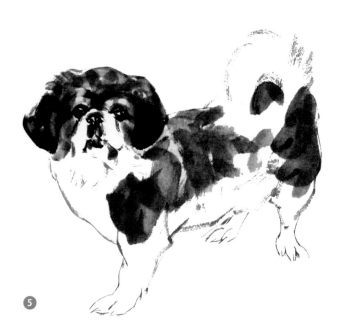

⑤

before the clear water from the base of the brush dilutes it, which then becomes the light ink. (Fig. 3)

The dog's posture is another important element in a painting. Please take a close look at the two dogs in the drawing. They have exactly the same head, but with different postures. In other words, changing the angle of the body will produce a different look. (Fig. 4)

On the other hand, changing the orientation of the head will change the pose. If you compare this picture with Fig. 8, you will notice that the two dogs have the same postures, but the angle of their heads is different. The dog in Fig. 4 looks straight at you while the dog portrayed in Fig. 8 has his head slightly tilted to one side. The slight difference between the orientation of their heads creates two different vivid images. While painting, pay close attention to the variation of the shade of the lines, thickness of the lines, and wet control. In Chinese painting, there is no transparent painting technique to separate the foreground from the background of a painting. The difference between the foreground and background objects are achieved by the shades of the lines. In other words, paint the foreground in dark ink and paint the background in light ink. (Fig. 5)

6

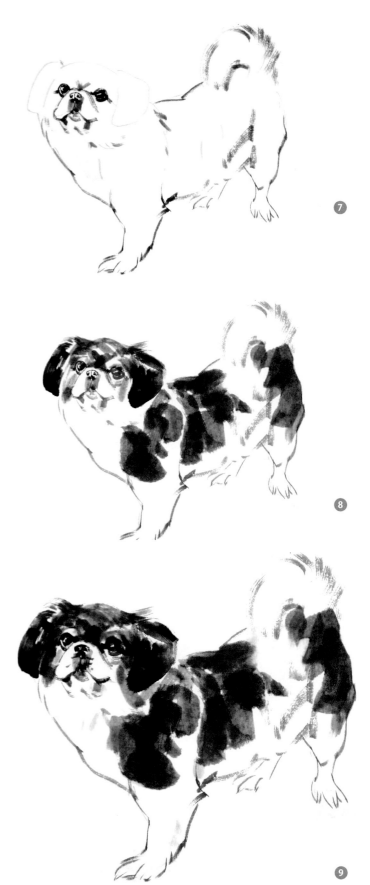

7

8

9

Painting a Burnt Sienna Pekingese

The Pekingese is also called the Beijing Dog. It is an ancient breed of toy dog, originating from China 4,000 years ago. The breed, commonly referred to as "Lion Dog," was a favorite of the Chinese imperial court. It has a heavy front body and light back body, with a resemblance to the Chinese guardian lions. The Pekingese usually greets you with dignity and pride. They are very intelligent, brave, and tough, but that intelligence is offset by an independent mind and a wide stubborn streak. Pekingese are very loving and affectionate with their families, but aloof, almost wary, of strangers. These characteristics make them popular domestic pets and show dogs.

1. First, use a pencil or charcoal to sketch out the head and body, and then paint the eyes and nose in dark ink. Lastly, paint its mouth in light ink. (Fig. 6)

2. Pekingese usually have pure white hair, therefore, make sure the lines of the body are painted in light ink. (Fig. 7)

3. Dip the brush in burnt sienna to paint the dog's body where the burnt sienna color is shown in Fig. 8. Apply different shades of burnt sienna to the dog's head and body parts. Then tip the brush with dark ink to paint its ears. (Fig. 8)

4. To finish, touch up the shady parts of the body with dark ink. (Fig. 9)

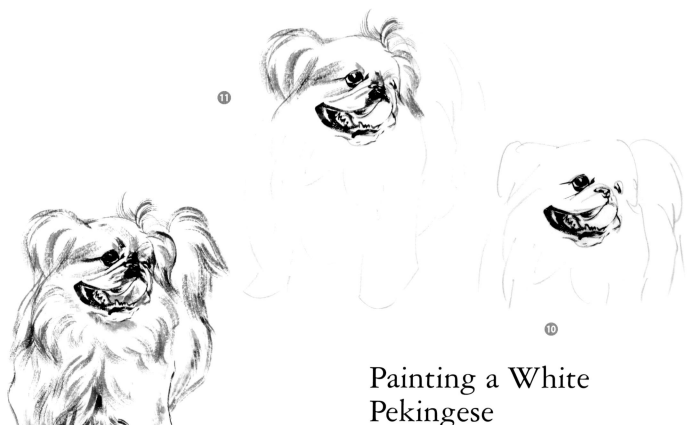

Painting a White Pekingese

The Pekingese's coat is long, soft, and shiny. It is not too thick nor is it too thin. Long feathering is found on the backs of the legs and on the toes. The Pekingese also has a noticeable fluffy mane on its neck.

1. The Pekingese's massive flat and wide top skull gives it a unique look. The muzzle is broad, flat, and thick below the two round bulging eyes. It has a broad and short nose with two wide open nostrils. Its two ears lie flat against its head. First, lightly sketch out the dog with a pencil, and then use ink to paint its lines and texture. Erase the pencil sketches before finishing it. Make sure the drawing is accurate and vivid. (Fig. 10)

2. The Pekingese has a stocky and muscular body with long hair. First, press your brush open in the palette, and then paint the texture of its hair with an s-shape stroke using the feather-edging technique. (Figs. 11, 12)

3. To finish, paint the tongue in a light carmine color. This completes the painting of a lively Pekingese. (Fig. 13)

Painting a Dalmatian

The Dalmatian is noted for its unique black-or-brown spotted coat. It is calm, alert, and intelligent. It is a great companion for children. The body structure of the Dalmatian is totally different from the Pekingese. Dalmatians vary from medium to large sizes. They usually have slim, but strong muscular bodies, and are built proportionally.

1. While painting the Dalmatian, it is important to demonstrate such features as a slim body shape and strong muscle tone. Like painting the Pekingese, first sketch out the Dalmatian with a pencil, then paint the lines and texture with ink. Erase the pencil sketch after painting. Since the Dalmatian has a white coat, use light ink to paint its hair in fine lines. (Fig. 14)

2. Outline the upper body of the Dalmatian in dark ink using heavy pressure and slow brush strokes. (Fig. 15)

3. Use light ink to paint the back legs to convey a sense of depth. In Chinese painting, there are no transparent painting techniques to separate the foreground from the background of a painting. The difference between the foreground and background objects is achieved by the shades of the lines. To accomplish this, paint the foreground in dark ink and paint the background in light ink. (Fig. 16)

4. Load your brush with a light wash of ink or dip it in very light ink. Paint the muscles of the head and body in very light ink. (Fig. 17)

5. Before the ink on the body totally dries up, dot the body randomly with dark ink. When the ink is absorbed by the rice paper, it creates an illusion of the fluffiness of the hair. To finish, paint the tongue in a light carmine color. (Fig. 18)

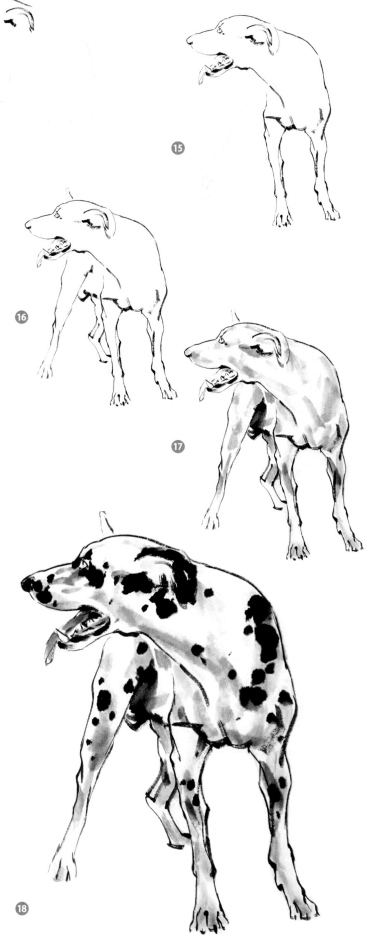

Horse

In ancient times, horses were essential to human beings in farming, transportation, and warfare. They are extremely intelligent and attentive. They look elegant, but work very hard. In Chinese culture, horses represent the symbol of power. The Chinese proverb about "horses leading the way" (*yi ma dang xian*, 一马当先) describes the courage of never being intimidated by any hardship. Therefore, horses have become one of the favorite subjects of Chinese artists.

In this chapter, we will show how to paint horses in the slight freehand style. The outlining technique will better demonstrate the muscle tone of the horse while the dark ink color will show its movement.

Chinese paintings focus on expressing the spirit of a subject through the composition of the work. The painting will be more vivid if we can combine the look with the spirit. When painting horses, it is extremely important to reflect the spirit of the horse from its look. Pay special attention to the changes of its body shape, especially the tail, the mane, and the legs under different circumstances, such as running and resting.

Basic Techniques

A horse has a long head with a flat face. Take a close look at the 6 horse heads in the picture. From the front view, the eyes of the horse and mouth form a narrow upside down triangle with two short ears. The distance between the two ears is just the same as the width of the head. From the side view, its one eye lines up with the nose in one straight line. The whole head is in the form of a long triangle. (Fig. 1)

The body structure of a horse can be portrayed by many lines. When painting, pay attention to the variation in the thickness of the lines and the ink shading. Use thick lines to paint solid muscles and use thin lines to paint lean areas. We can also show the change of the muscle movement by different lines. It is important to use the appropriate size and proportion in painting the muscles to enhance the sense of strength. In Chinese painting, there is no perspective

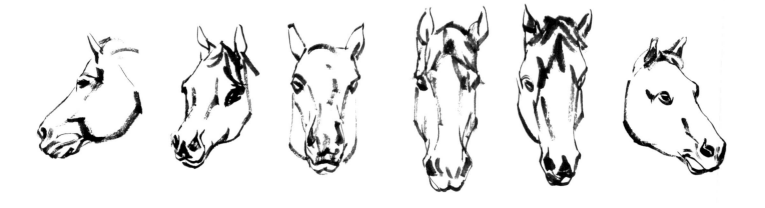

❶

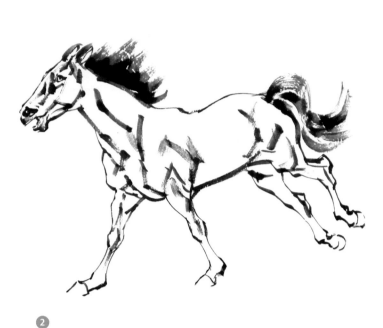

2

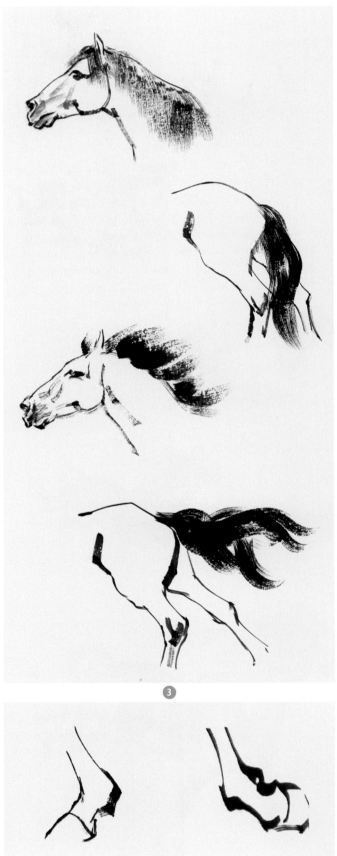

technique to separate the foreground object from the background objects like Western paintings. Instead, we stick to the principle of "painting the foreground objects in dark ink and the background objects in light ink." This is also the technique that we use in the painting to show the position of the four legs and its running movement. (Fig. 2)

The change in the movement will also cause many changes in the look of the mane and the tail of a horse.

For a resting horse, its mane hangs down and the end of it is a little bit curled. The mane and the hair around its ears appear to be very soft. For a running horse, it looks more alive if we can paint its mane flying in the wind and its tail flowing with the body. Use dark ink to paint the mane with centered-tip strokes to show a sense of flying. The freehand style of the painting technique will express the beautiful movement of the horse. The tail should be painted in a shape like an inverted "S" with a big arc to show the softness of its texture. (Fig. 3)

Every horse leg has one hoof. On your draft, you can draw a triangle or an irregular quadrilateral to represent a hoof. Then outline the hooves with thin lines. (Fig. 4)

3

4

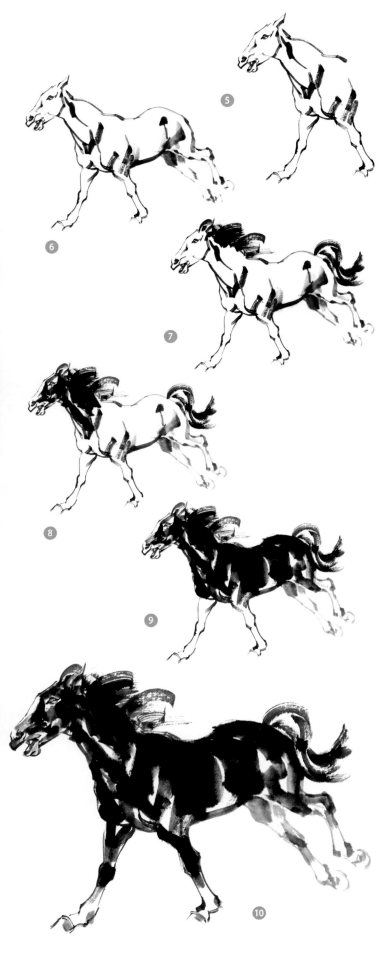

Painting a Running Black Horse

A running black horse is like a dark lightening in the wind.

1. First sketch out the running horse with a pencil, and then outline its head, neck, front part of the body, and the two front legs in dark ink. Since it is a black horse, the lines on the neck can be dark and thick to show the strength of the muscles. If it is a white or a golden-colored horse, you may use light ink. (Fig. 5)

2. In this painting, since the horse is running forward, the front body of the horse is closer to the viewer based on the principle of "painting the foreground objects in dark ink and the background objects in light ink." Then outline the back part of the body and its two back legs in light ink. Make sure the two back hooves are slightly lifted up to show the movement of running. Add a few more strokes at the joints between the body and four legs to show the layers of muscle. (Fig. 6)

3. Paint the horse's mane and tail by following the method introduced in the Basic Techniques section above, which will increase the dynamic of its movement. (Fig. 7)

4. Paint the head and neck in dark ink, leaving some highlights on its neck and around its eyes. (Fig. 8)

5. Paint the body in dark ink, leaving some highlights on the body based on the muscle structure. You may apply the dark ink on the body roughly to show the muscularity of a male horse and its strong and healthy movement while running. (Fig. 9)

6. Soak your brush in dark ink to paint the two front legs. Wait until the dark ink lightens before painting the two back legs in light ink. Horses have different colors, and so do their legs. Some are in total black while some are in partial black. Therefore, you can either leave the hooves white or black. (Fig. 10)

Painting a Light-grey Horse at Rest

This picture portrays a light-grey colored horse with some markings. One of the slight freehand style methods is to use the outlining technique first, and then to add color. Compared to the other slight freehand style method, i.e. using ink only, this method can show more details in portraying the tamed and peaceful expression of a horse while it is at rest.

1. While a horse is at rest, his head is generally slightly lowered. Paint this picture by following the basic techniques on how to paint the horse head. First sketch out the head with a pencil, and then outline the face in dark ink, highlighting its eyes and nose. (Fig. 11)

2. In this painting, the back part of the body is closer to the viewers than the front part of the body. Following the principle of "painting the foreground objects in dark ink and the background objects in light ink," outline the front part of the body including the two front legs in light ink. (Fig. 12)

3. Then outline the back part of the body including the two back legs in dark ink. Pay attention to the leg positions. The two front legs are extremely straight while the two back legs are slightly bent. Next, paint the tail hanging straight down in dark ink with some curly hair at the end. Then paint the soft mane and the hair around the ears in dark ink as well. (Fig. 13)

4. Press your brush open, and then paint some peach blossom dots on the bottom of the horse in light ink. The markings should be irregular and dotted randomly. Wait until the ink lightens before applying the same method to add markings on the front part of the body, the head, the neck, and the two front legs. (Fig. 14)

5. Soak your brush in the ink water to trace the outline of the body, detailing the stomach and the head to show the depth of the muscles. (Fig. 15)

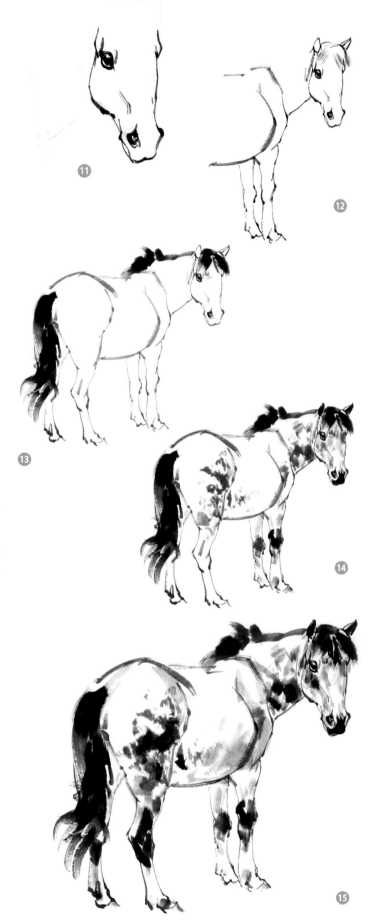

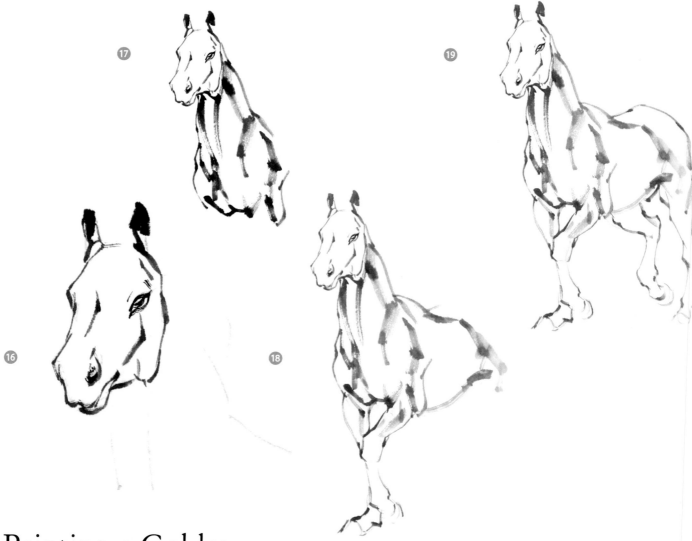

Painting a Golden-colored Running Horse

This painting shows a golden-colored horse that is running slowly.

1. Sketch out the horse with a pencil first. In this painting, the head of the horse is slightly turned to one side. The eye on that side lines up straight with the nostril on the same side. Outline the head in light ink. Paint the inner side of the ears in dark ink to show the shady area. (Fig. 16)

2. Then outline the neck of the horse with varying thickness of the lines to show the well developed muscles around the neck. (Fig. 17)

3. Because it is a golden-colored horse, outline the front part of its body and the two front legs in light ink. One leg is slightly bent and moving forward, and the other leg is straight on the ground. (Fig. 18)

4. In this painting, the back part of the body and the two back legs are further away from the viewer, therefore they should be painted in lighter ink. The movement of the back legs should be coordinated with the movement of the front legs. The front right leg is slightly bent, and so is the left leg at the back. The front left leg is straight, and so is the right leg at the back. This shows the unique movement of each leg while the horse is running. The two hooves of the two bent legs should be lifted up slightly towards the back. (Fig. 19)

5. Paint the joints of the four legs in dark ink. Do the same to the mouth. Wait until the ink lightens before adding a few strokes along the lines of the body to show the contrast between the dark and the

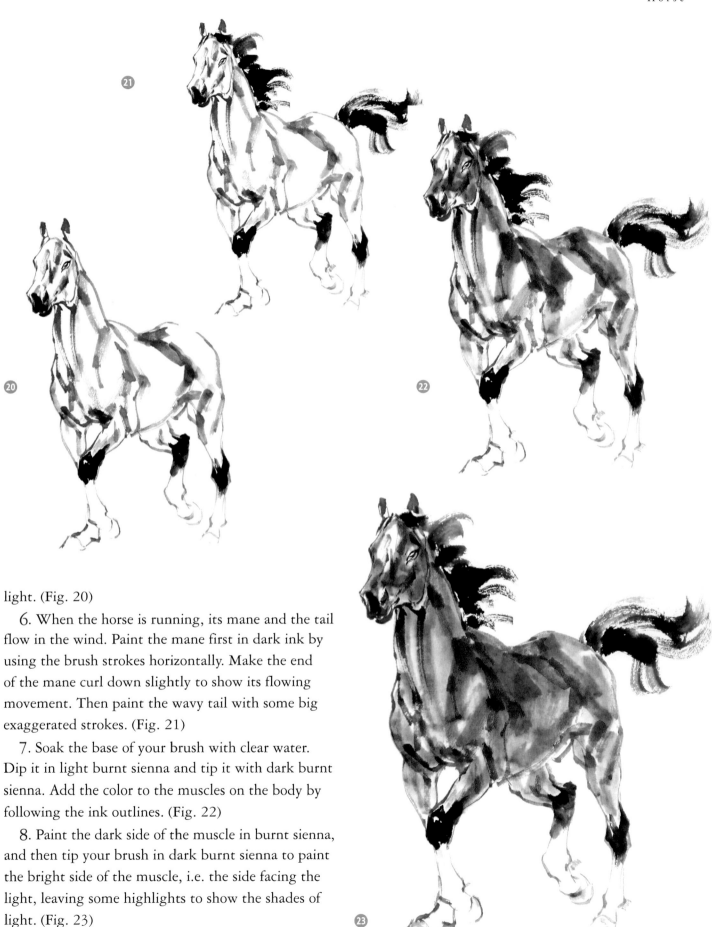

light. (Fig. 20)

6. When the horse is running, its mane and the tail flow in the wind. Paint the mane first in dark ink by using the brush strokes horizontally. Make the end of the mane curl down slightly to show its flowing movement. Then paint the wavy tail with some big exaggerated strokes. (Fig. 21)

7. Soak the base of your brush with clear water. Dip it in light burnt sienna and tip it with dark burnt sienna. Add the color to the muscles on the body by following the ink outlines. (Fig. 22)

8. Paint the dark side of the muscle in burnt sienna, and then tip your brush in dark burnt sienna to paint the bright side of the muscle, i.e. the side facing the light, leaving some highlights to show the shades of light. (Fig. 23)

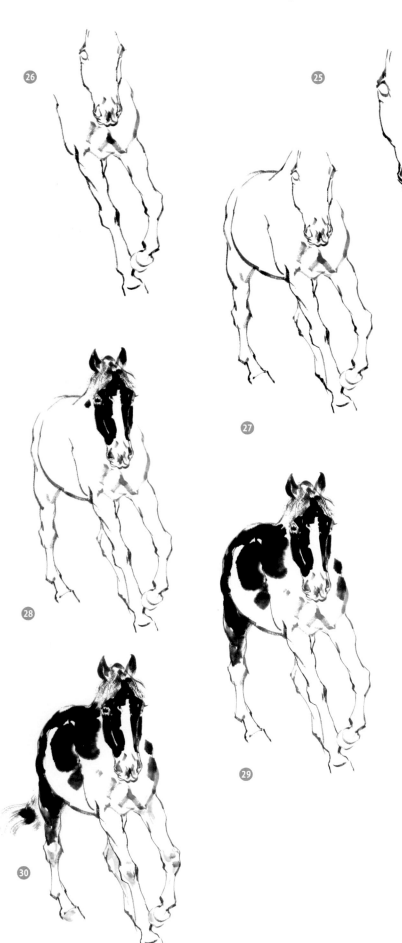

A Showcase

This painting portrays a horse galloping on fresh green grassland in spring through the willow trees.

1. Sketch out the horse with a pencil. In this painting, the horse has a long face and is looking straight ahead. The two eyes are positioned on the top one-third of the face. Then outline the eyes in dark ink with a brush. (Fig. 24)

2. Outline the face of the horse with dark lines. (Fig. 25)

3. Outline the front part of the body and its two front legs in dark ink since they are closer to the viewer in this painting. (Fig. 26)

4. Outline the back part of the body and the two back legs in light ink, making sure that they are coordinated with the two front legs. (Fig. 27)

5. Paint the face and ears in dark ink, making sure to leave some highlights around the eyes. Add some hair to the connecting area between the ears and the face in light ink. (Fig. 28)

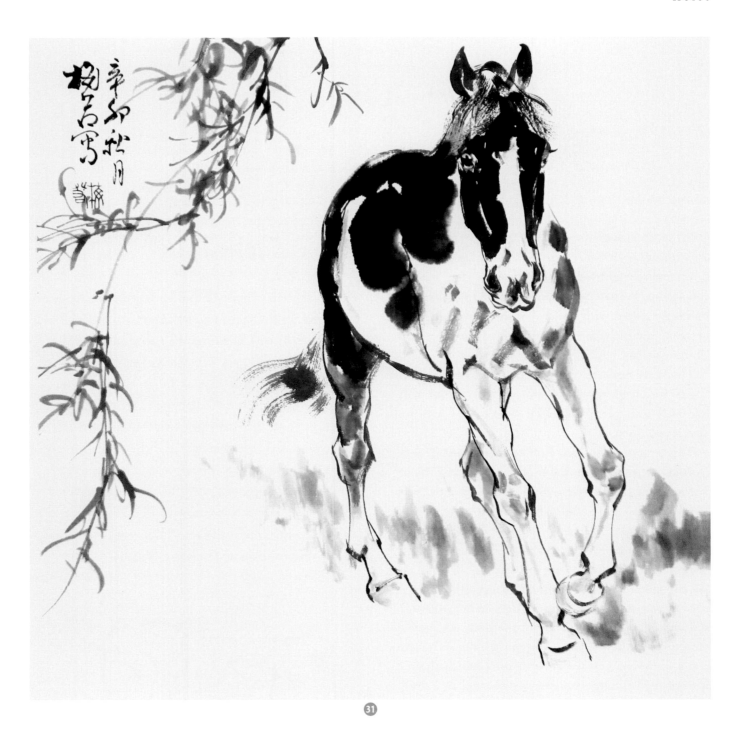

③①

6. Soak your brush in dark ink, leaving some clear water at the base of the brush. Paint the markings on the back and the back legs in dark ink and let it bleed through the rice paper naturally. Make sure that you leave some water at the base of the brush, otherwise the dark ink won't bleed. (Fig. 29)

7. After the ink lightens, paint the tail, which is mostly covered by the body, with a curl at the end.

Then paint the outline of the body and the joints of the legs in light ink or ink water to give a three-dimensional feel. (Fig. 30)

8. Add some fresh green grass under the hooves and some willow leaves on one side to enhance the background. You may select the shade of green based on your preference and design. Sign your painting. This completes the art work. (Fig. 31)

Ox

Oxen symbolize civilization in farming. They are honest and labor quietly at their daily tasks, unremittingly and without complaint. They are essential to human beings in farming. In China, literature is rich with praises on the characteristics of oxen, making them one of the favorite subjects of Chinese artists.

The body features of an ox include a big head with a wide forehead, nose, and mouth. It has a low and flat back with a long tail and a strong body with well-developed muscles.

This chapter will show how to paint oxen in the freehand style. Depending on the position of the ox, if it is at rest or in movement, it can be painted with either the fine and detailed style or the exaggerated and liberal style. The two important elements in painting oxen are the proper application of the ink color and controlling of the ink shading. If you are a beginner, you will gain proficiency through continuous practice of the painting techniques and acquiring the knowledge about the body and muscle structures of the ox. Once you master the techniques and knowledge, you will be able to combine them with your imagination to create paintings that are good at expressing the spirit of the subject.

Basic Technique

The head of an ox has the similar features to the head of a horse, but it is even wider. The two ears look like big open fans with their tips on the same line. The space between the ears will change with the angle of the head. Take a close look at an ox whenever you get a chance. You will notice that the two bright eyes are big and round. From the front view at a slight angle, you will see that the two eyes and the nose form a triangle. From the side view, you will see that the mouth lines up straight with the nose. You need to master these basics to create a vivid image of the head before you can create different body positions based on the various looks of the head. (Fig. 1)

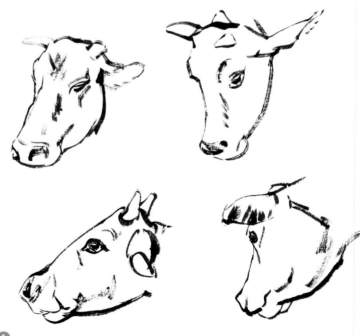

①

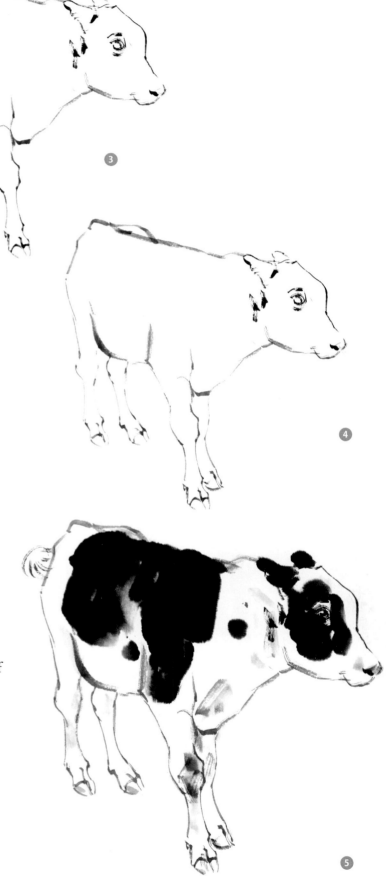

Painting a Calf in the Slight Freehand Style

This is a small calf with markings on the body. Though it has a tiny body, it is very lovely.

1. Sketch out the head with a pencil. Pay attention to the important features, such as the eye lining straight up with the nose. The eye should be big and placed in the center of the head. After sketching, outline the eye, the nose, and the ear in dark ink. (Fig. 2)

2. Outline the front part of the body and the two front legs in light ink. The back of the ox should be flat and even. The hoof is in the shape of a diamond. Divide the right toe from the left toe by drawing a line in the middle of the diamond. (Fig. 3)

3. Outline the back part of the body in lighter ink. (Fig. 4)

4. Due to the angle of the body, only a little part of the tail can be seen. Paint the end of the tail in light ink by using a few curve strokes. Tip your brush with dark ink to add dark markings on the areas around the ears, eyes, shoulders, and the back by using the centered-tip strokes. The markings should be dotted randomly, but they must show the variations in ink shading. Soak your brush in ink water and paint over the chest and joints of the legs to show the depth of the body structure and to create a 3D effect. (Fig. 5)

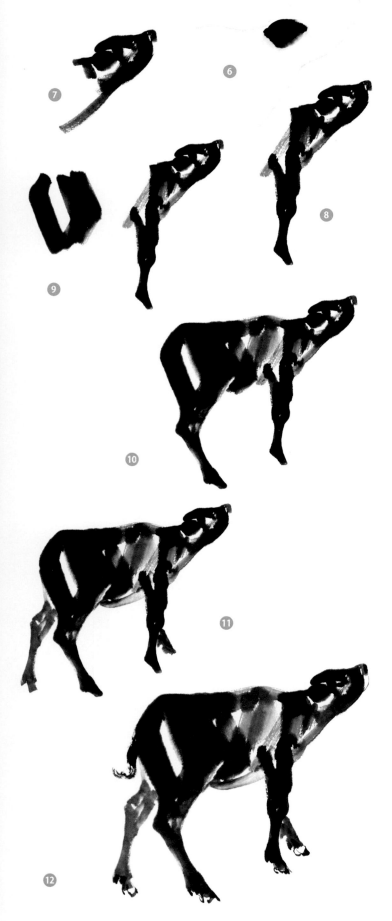

Painting a Black Ox in Great Freehand Style

Compared to the slight freehand style, the great freehand style is a more sophisticated method, because it creates paintings with abstract shapes by using ink color only. The great freehand style requires extensive knowledge of the body structure of an ox and a high level of proficiency in mastering the brushing techniques and the control of ink shading. You may first make a sketch. Once you become skillful, you can paint the picture without sketching it out first.

1. Sketch out the head with a pencil, angling it upwards. The head should be in the shape of a triangle that is arced to one side. Paint the ear in dark ink after sketching. (Fig. 6)

2. Use one up stroke and one down stroke to complete the ear. Then finish the head and adding the nose at the tip of the head. (Fig. 7)

3. Paint the shoulder and the front legs with one down stroke in dark ink. Make sure they are well connected. Make some modification if necessary. (Fig. 8)

4. After sketching out the rear part, paint it in dark ink by using the centered-tip strokes, making it look like a parallelogram. (Fig. 9)

5. Add one back leg to the rear. After the ink lightens, cover the middle part of the body with light ink, leaving some highlights. (Fig. 10)

6. Add the other back leg with the rest of the ink. Outline the lower part of the belly. Pay attention to the position of each leg. You may use the techniques illustrated in the chapter on the Horse on page 46. (Fig. 11)

7. Tip your brush with dark ink, and then add a hoof to the bottom of each leg. Since the hooves are painted in the great freehand style, they will appear in the abstract shape of a diamond. Lastly, paint the tail. (Fig. 12)

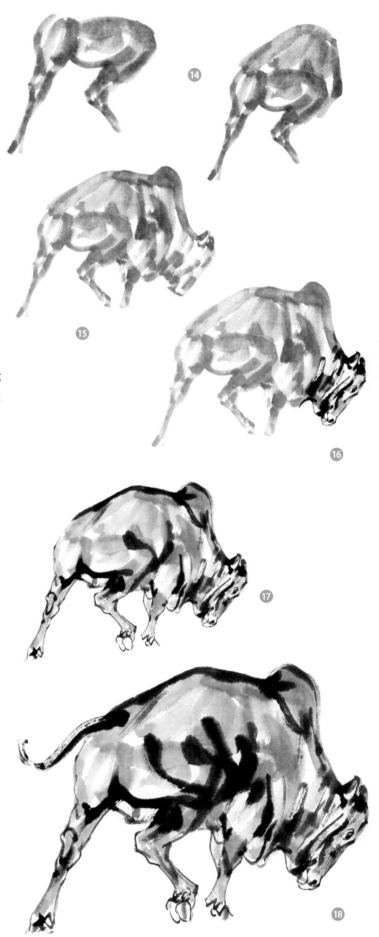

Painting a Bull in the Great Freehand Style

In Chinese painting, the fine lines are weak at expressing excited movement. Therefore, it is recommended to use an exaggerated style. First, form the shape of the body by using several strokes of the light ink, and then outline the body with the exaggerated dark lines.

1. Sketch out the body with a pencil. Because this painting is about a bull in fighting, the bull's left back leg should be extremely straight, pushing against the ground to support his body. The back leg on the right should be bent forward. Outline the shape of the back legs in light ink first before painting it in dark ink. (Fig. 13)

2. Its back should be in a big arc. Outline the shape of the back in light ink first before painting it in dark ink. (Fig. 14)

3. The front legs should touch the ground with the shoulders arched and the head pointing towards the ground. Use the same method by outlining the shape in light ink first before painting it in dark ink. (Fig. 15)

4. Trace the outline of the head with dark ink to highlight the features of the face including the mouth, nose, and eyes. (Fig. 16)

5. Highlight the shoulders, back, rear, legs and the joints that connect to the body in dark ink with exaggerated thick lines to show the intensity of the movement during the bullfighting. Tip your brush with light ink to outline the hooves of the four legs in fine lines. Pay special attention to the back leg on the right. The hoof on that leg looks different because it is bent. You can paint it with two half circles. (Fig.17)

6. When painting the tail, make the end of the tail curl with a big arc. Outline the shape of the tail in light ink first before painting it in dark ink. (Fig. 18)

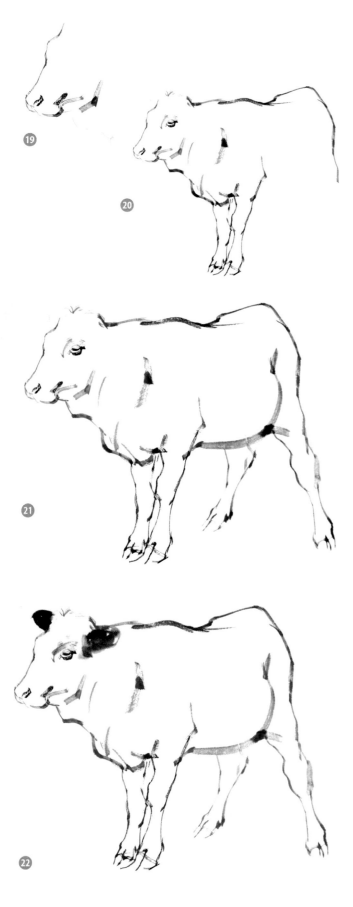

A Showcase

This painting portrays an old ox that is quietly standing there as if he is taking a break from plowing in the field.

1. Sketch out the head with a pencil, and then outline it in dark ink. Make sure the outline above the eyes is bulged out slightly to show the 3D effect. The nose should be placed in the center above the mouth. (Fig. 19)

2. Outline the front part of the body, the front legs, and the rear in dark ink. The two front legs are set straight with two clearly defined hooves. The rear needs to be arched slightly. (Fig. 20)

3. Base on the principle of "painting the foreground objects in dark ink and the background objects in light ink," outline the lower belly and the two back legs in light ink. The two back legs should be separated apart. (Fig. 21)

4. Paint the right ear in dark ink, and then dip your brush in burnt sienna to paint the left ear. (Fig. 22)

5. Keep some clear water in the base of your brush, and then dip your brush in burnt sienna to add color to the areas of the body, including the two sides of the face, the shoulders, and the rear. (Fig. 23)

6. Load your brush with ink water to paint over the outline of the body and legs. Make sure to show the depth of the muscle by creating the contrast between the dark and light ink. (Fig. 24)

7. Dip your brush in dark burnt sienna to add color to the upper shoulders next to the head, the joints between the body and the front legs, and the joints of the front legs and the hips. Paint the tail after the ink lightens. (Fig. 25)

8. Add some grass and branches under the hooves. You may choose the color of the grass and branches to match the color of the ox. Sign the painting. This completes the art work. (Fig. 26)

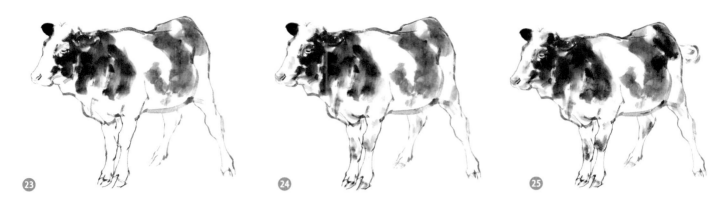

23 24 25

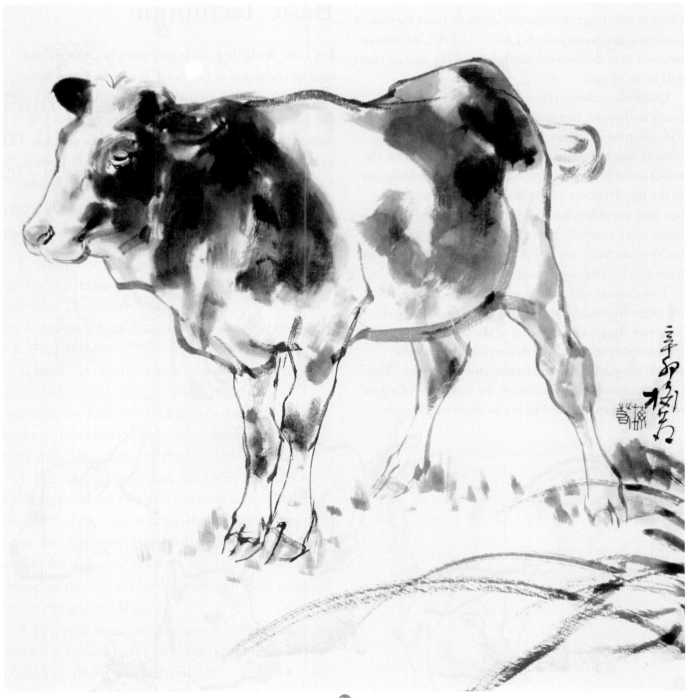

26

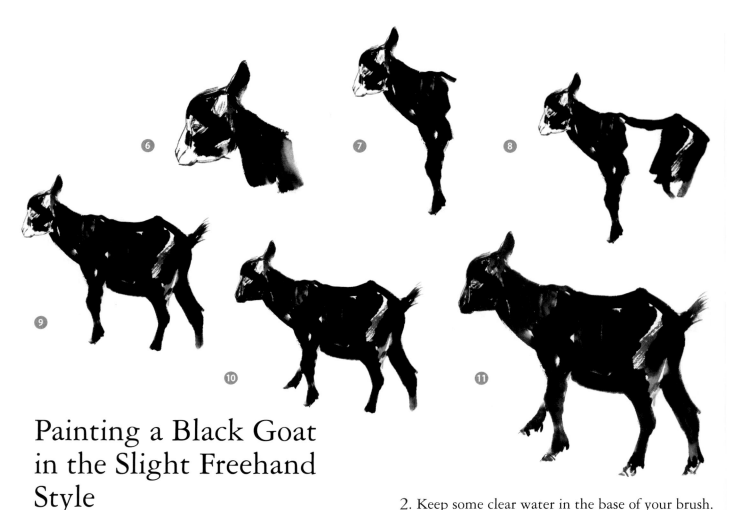

Painting a Black Goat in the Slight Freehand Style

The Chinese painting techniques include "dot, line, and patch." Here, the "patch" refers to the solid heavy strokes in a dark shade of ink. The highest level of proficiency in Chinese paintings is to master the techniques of applying solid heavy strokes in dark ink. The black goat has a medium size figure and a rectangular body with black hair. The solid heavy strokes in dark ink will show the solid muscle structure of the goat.

You don't need to make a sketch if you are very familiar with the body structure of the goat, and are very skillful in using the techniques. However, to attain that high proficiency, it takes a lot of practice in painting and observing the goat.

1. Outline the shape of the goat with a pencil. Position the head and the erected horn in the painting. Dip your brush in dark ink to paint the head and the neck, leaving some highlights around the ear and the eye. (Fig. 6)

2. Keep some clear water in the base of your brush. Dip it in dark ink to paint the front part of the body and one front leg by using one down stroke from the neck, leaving some highlights. The water in the base of the brush will keep the ink wet. (Fig. 7)

3. Paint the back of the goat in dark ink, making the back line slightly concaved, and then paint the rear, leaving some highlights. The outlines of the back and the rear can be painted with some sharp edges. (Fig. 8)

4. Paint the two back legs in dark ink. Outline the belly in one stroke with the line extending slightly outward. Paint the body with the rest of the ink, leaving some highlights again. Press your brush open to paint the tail, pointing it upward. (Fig. 9)

5. Paint the front leg on the right side in light ink. (Fig. 10)

6. Add the carmine color to the ear. "Dot" the hooves at the bottom of the four legs using the abstract style. (Fig. 11)

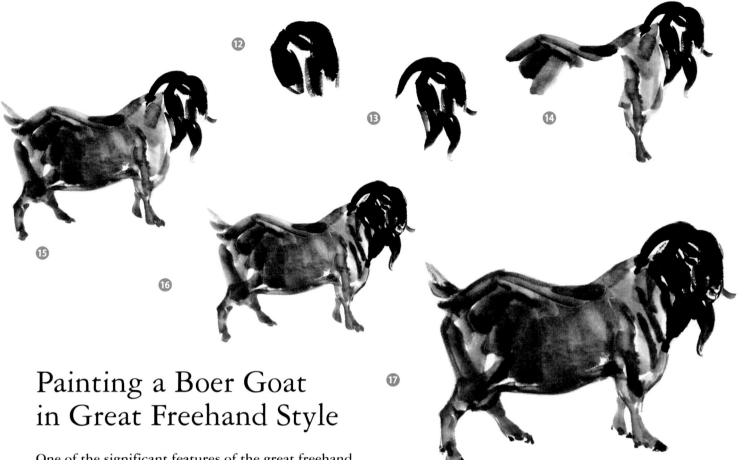

Painting a Boer Goat in Great Freehand Style

One of the significant features of the great freehand style is to paint with solid heavy strokes in black ink. Compared to the slight freehand style, this is a more exaggerated painting style which combines the thick lines with solid heavy strokes. Although this style simplifies the details of the "portrait," it reflects the "spirit" of the goat.

The Boer goat originated from Germany. It has a solid body with brown hair on the head and white hair on the body. Paint the head in dark ink and the body in light ink.

1. Make a sketch with a pencil. The Boer goat has long dangling ears with thick horns. Make sure to highlight these features in your painting. Paint the head with solid heavy strokes in dark ink by following the triangle in the sketch. Keep some water in the base of the brush so that it will keep the ink flowing well. (Fig. 12)

2. On the top of the upside down triangle, paint two downward arcs from thick line to thin line which represents the two horns of the Boer goat. Then at the bottom of the upside down triangle, paint several short arcs to show the dangling ears. (Fig. 13)

3. Paint the front legs, the back, and the rear in light ink. The line of the back should be concaved. Make sure to keep the ink in a light shade. Press your brush wide open on the rice paper so that it creates bigger solid patches of black ink which will enhance the toughness of the goat. (Fig. 14)

4. Paint the two back legs in light ink. Make sure that one leg is in front of the other and both are slightly bent. Then outline the belly in one stroke and paint the front leg on the left. Paint the tail pointing upward in three strokes. Finally, paint over the body in light ink. (Fig. 15)

5. Outline the nose, the mouth, and the eyes in dark ink. (Fig. 16)

6. Add a few dots to the bottom of the four legs with dark ink to depict the hooves. (Fig. 17)

Pig

Chinese people consider the pig as a symbol of good luck. It is always associated with gold to represent the flow of money coming your way.

This chapter will show how to paint pigs in the slight freehand style. The pig has a very simple body structure that requires fewer details when painting, but on the other hand, it also makes the painting visually less rich. However, the slight freehand style can illustrate the most unique feature of the pig, i.e. its smiling face in vivid detail. As long as you capture the smile and combine it with various movements, your painting will be dynamic.

When creating a Chinese painting, it is very important to capture the most unique body feature of an animal. You need to not only show the contrast between light and dark shades of ink, but also to combine various body positions, which includes being idle and in motion in your painting. This will enhance the color and dynamic of your painting.

Basic Techniques

The pig's face has a long snout, a big mouth, and two huge dangling ears that look like big fans. From the side view, the head looks like an isosceles triangle turned 90 degrees clockwise. The bottom line of the triangle represents the neck. The two sides of the triangle form an arc at the connection, which

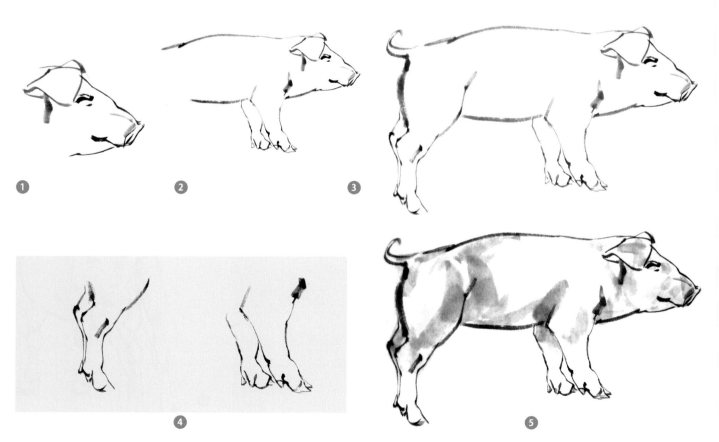

1 2 3

4 5

represents the big mouth. The ear is also in the shape of an upside down triangle. (Fig. 1)

Pigs have fat bodies with four short stubby legs. Since it lacks muscle, it is important to show its roundness in your painting. (Fig. 2)

The pig's tail is short and slim. It usually curls upward. (Fig. 3)

Pigs, oxen, and goats are all cloven-hoofed animals. Once you know how to paint the hooves of one animal, you can apply the same technique to the other animals. Pigs have four hoofed toes. The two front toes stay on the ground while the two back toes lift up slightly. In your sketch, use little triangles to show the four hoofed toes. The two front toes are bigger than the two back toes. The left side of Fig. 4 shows the two back hooves and the right side shows the two front hooves. (Fig. 4)

The hair on the pig's body is short and transparent. The body is usually white in color, so outline the pig in light ink. Paint over the rear, the stomach, the back, the neck, and the ears in lighter ink or ink water to show the 3D effect. (Fig. 5)

Painting the Panda Pig in the Slight Freehand Style

Liang Tou Wu, also known as the Panda Pig, is a unique species in China. It is also a typical type of Chinese pig. Because it has black hair on the neck and the rear, and white hair on the rest of the body, it is called *Liang Tou Wu*, which means two ends are black. The little Panda Pig has small ears and a short snout with fewer wrinkles on the face. It has four tiny legs as well. If you look at it closely, you will find it to be a very cute animal.

1. Make a sketch with a pencil. Since it has a short snout and small ears, make the angles wide on both sides of the triangle. The ear occupies less than one fourth of the head. Outline the head in dark ink. Use two or three lines to show a few wrinkles on the forehead. (Fig. 6)

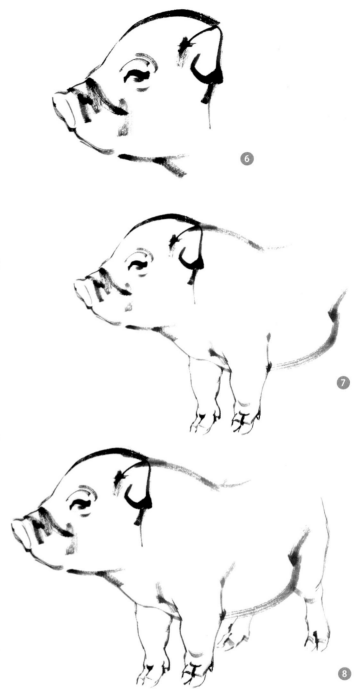

2. Outline the front part of the body and draw a big arc of the lower belly to show the roundness of the body. Outline the two front legs in dark ink. Paint the two front hoofed toes in great detail. (Fig. 7)

3. Following the principle of "painting the foreground objects in dark ink and the background objects in light ink," paint the two back legs in light ink. No matter if it is the front legs or back legs, they should all be short and stubby. (Fig. 8)

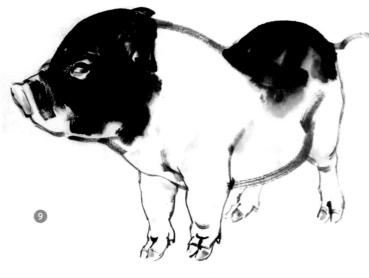

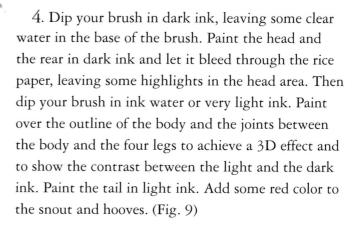

4. Dip your brush in dark ink, leaving some clear water in the base of the brush. Paint the head and the rear in dark ink and let it bleed through the rice paper, leaving some highlights in the head area. Then dip your brush in ink water or very light ink. Paint over the outline of the body and the joints between the body and the four legs to achieve a 3D effect and to show the contrast between the light and the dark ink. Paint the tail in light ink. Add some red color to the snout and hooves. (Fig. 9)

Painting Two Pigs in the Slight Freehand Style

In China, the pig represents good luck. Therefore, it is always presented with a big smile. You may use the exaggerated painting style to show the pig's smiling face, such as enlarging the size of the eyes and increasing the depth of the inward arc of the mouth. This image will appeal to many people and gives a touch of cartoon to the painting. Combining a black pig with a white pig in the same painting will enhance the richness of the color of the painting.

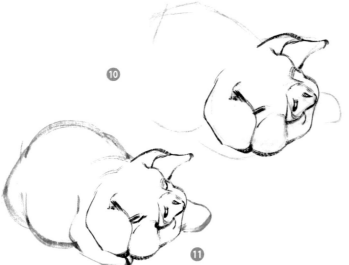

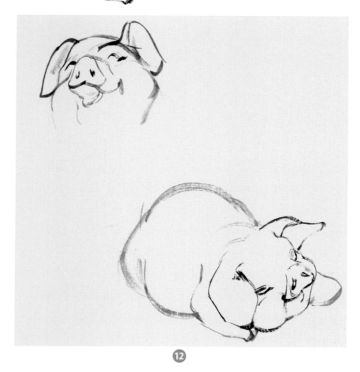

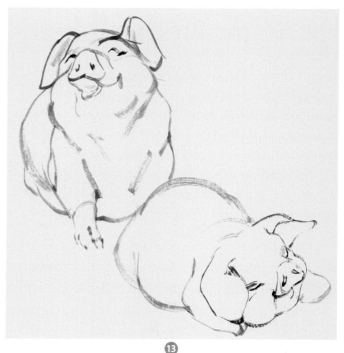

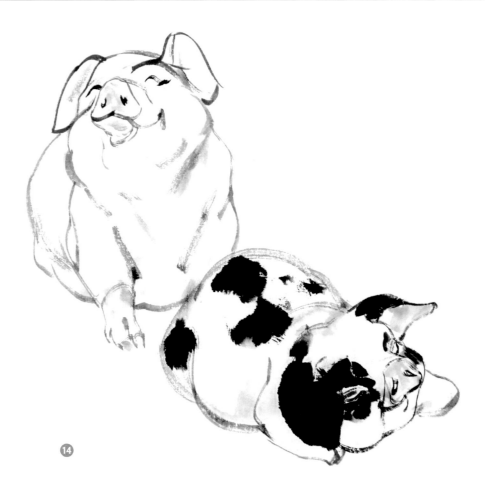

1. Before you sketch it out, plan out the theme of the painting and the positions of the two pigs. One pig is crawling on the ground while the other one is holding its head up with the front legs on the ground. Refer to Fig. 13 on how to make the sketch. The painting will definitely look lively with one pig's body curling up and the other stretching out.

The pig's head is in the shape of a regular hexagon with big angles. The two ears can be painted extremely big. The snout is in the lower middle part of the hexagon which can be painted as two circles. Use two upward lines to illustrate the two eyes as if they were closed. The eyes should be lined up with the top end of the snout. The body, the head, and the snout have to be big and round to reflect the rotundness of the body. After sketching, outline the head of the crawling pig first in dark ink. (Fig. 10)

2. Outline the little pig's body in dark ink with a big arc to show the roundness of the body. Lay the two front legs next to the head. (Fig. 11)

3. Outline the head of the other pig in dark ink. Make sure its mouth is slightly open and its eyes look like half moons. This gives the impression that the pig is laughing loudly. (Fig. 12)

4. The front leg of the pig with its head up should be painted clearly in detail. Use fine lines to paint the outline of the hooves. The body should be round and fat as a sign of good luck. (Fig. 13)

5. Dip your brush in dark ink, leaving some clear water in the base of the brush. Paint over the body of the crawling pig, including the rear, the back, the back legs, and areas around the ears and eyes. Let the ink bleed through the rice paper to show the patterns on the body. Use light ink or ink water to paint along the outline of the other pig's body. Make sure to create contrast between the light and the dark ink and to give a 3D effect. Paint the snout, the ears, and the hooves in light eosin. (Fig. 14)

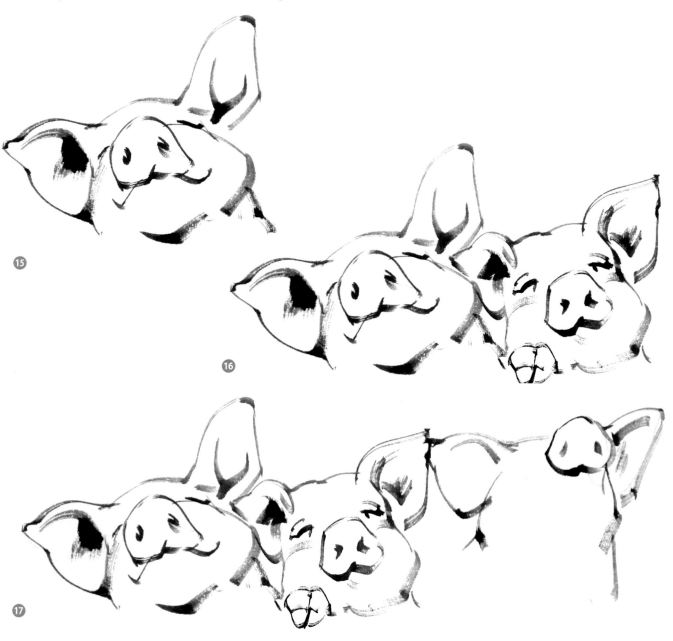

A Showcase

This painting portrays three cute little pigs in a basket.

1. Sketch out the three little pigs with similar body positions with a pencil refer to Fig. 18. Make them line up in one line. Apply the same techniques introduced to paint the pig holding its head up on page 65. Make the ears in the shape of two standing triangles and outline them in dark ink. Add a few strokes of dark ink inside the ears to show the shaded area. (Fig. 15)

2. Although the three little pigs have the same body positions, a slight difference among them will make the painting more unique. For example: make the head of the pig on the left tilt more to the left and hold its head up higher than the one in the middle. Use dark ink to paint a hoof under the head of the pig in the middle with fine lines. (Fig. 16)

3. Make the head of the pig on the right tilt more to

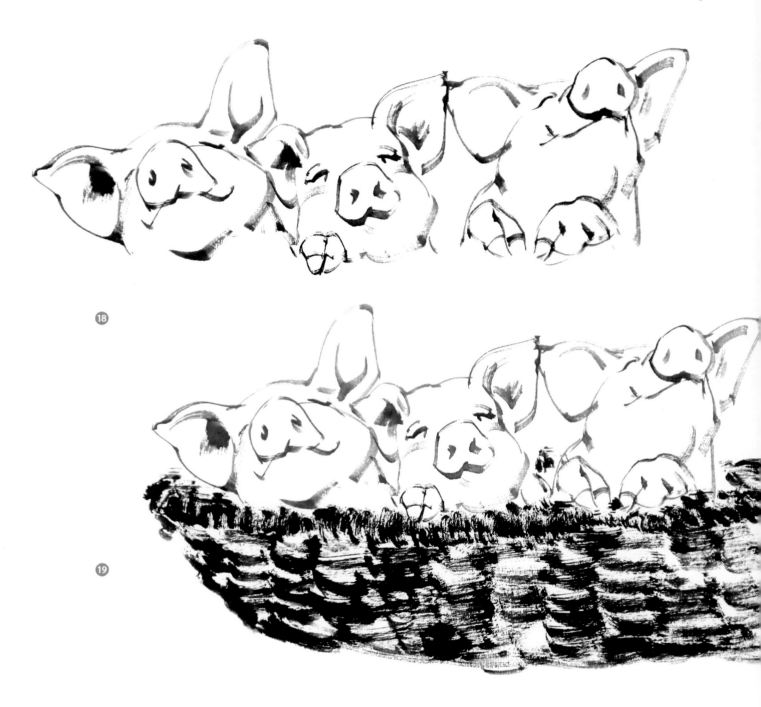

the right and hold its head up all the way to the ceiling. Its snout should follow the direction of the head and positioned at the upper right corner. This gives some variation to the original regular hexagon. (Fig. 17)

4. To match the position of the head, the eyes of the pig on the right should also be placed high, almost reaching the lines on the forehead. Add two little feet to the pig on the right. Paint the feet facing inward in dark ink with fine lines. To illustrate the smiling faces of the three little pigs, make the eyes

look like half moons and the corners of the mouths curving upward. (Fig. 18)

5. Add a basket under the pigs. Dip your brush in dark ink, keeping the brush a little dry. Create the top ring of the basket by using the dot technique. The dots should be intensely distributed. Then paint the body of the basket line by line. Put more lines in the center of the basket than the sides of the basket. Control the wetness of the brush while painting. It can be a little dry, but the ink has to be kept flowing. (Fig. 19)

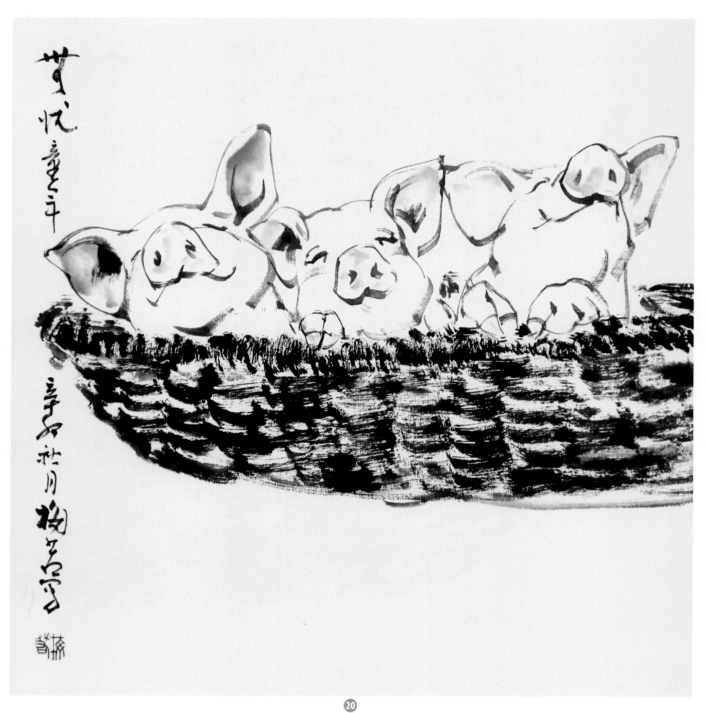

6. Paint the snout and ears in light carmine. Sign
your name. This completes your art work. (Fig. 20)

Appendices

Materials and Equipment for Chinese Painting

I. Brush

A Chinese painting brush can have soft or hard hairs or a combination of them. The brushes are made in large, medium and small sizes. The soft-hair brushes, generally of goat hairs, are very absorbent and suitable for dotting leaves and coloring. Wolf hairs make a hard brush that is tough and flexible and good for outlining leaf veins and tree trunks, among other uses. The combination brush is made of wolf and goat hairs. The brush is composed of the tip, the midsection, and the base (near the shaft).

Midsection
Base
Tip

II. Ink

Chinese painting is mainly done in ink, which is made from either lampblack or pine soot. Lampblack is darker, shinier and more suitable for painting. Pine soot is flatter and more suitable for calligraphy. In the past artists used to grind their ink sticks to make ink for their paintings; nowadays most artists prefer bottled ink. Choose the ink specially made for painting and calligraphy, otherwise the ink will fade after the painting is framed.

III. Paper

The paper used for Chinese painting is called *xuan* paper or rice paper. There are two kinds of rice paper: the mature rice paper, which is treated with alum to make it less absorbent, good for the detailed style of Chinese painting because you can apply many coats of colors without fear of undesirable blending; and the raw rice paper, which is untreated and absorbent, and suitable for the freehand style because the blending of ink and color can be used by artists to produce nuanced ink tones.

IV. Inkstone

The inkstone used for Chinese painting is made from aqueous rock, which is hard and fine-textured and produces dense ink when ground. The Duan inkstone, made from stone quarried in Duanxi in Guangdong

province, is the most famous of the inkstones in China. But people have turned to the more convenient bottled ink, which produces equally good results.

V. Pigments

The pigments used for Chinese painting are different from those used in western painting, and have different names. Pigments can be classified as water soluble, mineral or stone. Gamboge, indigo, carmine and rouge are some of the water soluble paints; mineral paints include beryl blue, malachite, cinnabar and titanium white. Burnt sienna comes under the "stone" rubric.

VI. Accessory Equipment

Water bowl for rinsing brushes, felt table cover, palette etc.

Use of Ink and Brush in Chinese Painting

I. Using Brush

Any stroke used in Chinese painting comprises three stages: entering the stroke, moving the brush along and exiting from the stroke. Some of the strokes are *zhong-feng* (centered-tip), *ce-feng* (side-brush), *shun-feng* (downstream), *ni-feng* (upstream), *ti* (lift), *an* (press), *dun* (pause) and *cuo* (twist-around) etc.

The centered-tip stroke moves along the center of the ink line with the tip of the brush. To execute the side-brush stroke, the brush is held at an angle, with the tip against one side of the line (point or surface), and moves with its midsection pressed against the paper. (Fig. 1)

The downstream stroke is used to paint from top downward or from left to right, while the upstream

stroke moves from the bottom upward or from right to left. (Fig. 2)

"Lift" the brush as it pulls along will make a lighter line. "Press" down on the brush to make a thicker and darker line. The "pause" stroke consists in pressing the brush into the paper or grinding and rotating the brush. Several "pause" strokes constitute a twist-around stroke. (Fig. 3)

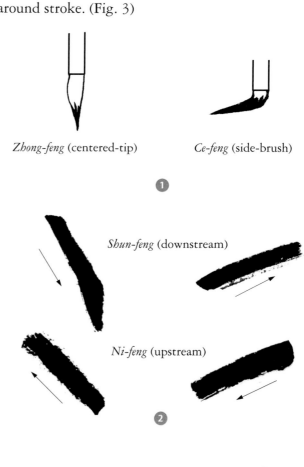

Zhong-feng (centered-tip) *Ce-feng* (side-brush)

1

Shun-feng (downstream)

Ni-feng (upstream)

2

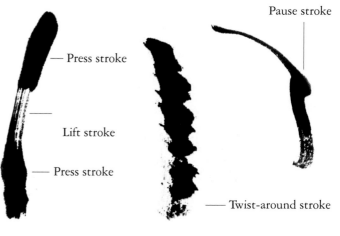

Pause stroke

— Press stroke

— Lift stroke

— Press stroke

— Twist-around stroke

3

II. Using Ink

In Chinese painting it is important to master the use of the following five gradations of ink: dark, light, dry, wet and charred (burnt). (Fig. 4)

Dark ink: Add a small amount of water to the ink to make a dark shade;

Light ink: Increase the amount of water in the mixture to make a light ink;

Dry ink: A brush that contains only a small amount of water can apply either dark or light ink;

Wet ink: The brush contains more water and can also apply either dark or light ink;

Charred ink: Very black shading that creates a shiny black effect on the paper.

Dark ink

Light ink

Dry ink

Wet ink

Charred ink

4

III. Using Brush and Ink

Brush and ink are mutually reinforcing. The wetness or dryness of the ink translates into the wetness or dryness of the brush to communicate the "spirit

of the ink." The use of ink and the use of the brush are closely interdependent. It is important to bear in mind these six words when using the brush: light, fast, side, heavy, slow, center. (Fig. 5)

Light: Lifting the pressure on the brush while the stroke is in progress;

Fast: Shortening the time of the stroke;

Side: Using the side-brush stroke;

Heavy: Pressing down on the brush while the stroke is in progress;

Slow: Increasing the time of the stroke;

Center: Using the centered-tip stroke.

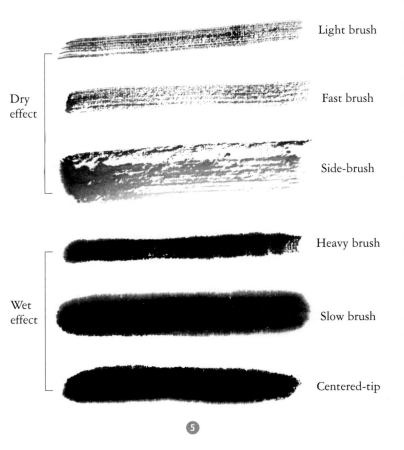

Dry effect — Light brush

Fast brush

Side-brush

Wet effect — Heavy brush

Slow brush

Centered-tip

5

It is common sense that when the brush has been soaked in water, whatever liquid in the brush will flow down faster when the brush is held upright and will run more slowly when the brush is held at a slant. In a centered-tip stroke the upright brush is pressed down and pulled at a more leisurely pace, the ink will consequently have ample time to be absorbed by the

paper and what results is a wet stroke. If the brush is held at an angle and is not pressed as hard against the paper and is pulled at a faster pace, there is less time for the paper to take in the ink; what results then is a "flying white" (broken ink wash effect), namely a dry stroke. It is therefore essential to learn how to properly manipulate the brush and ink.

Fig. 6 offers an analysis of the different kinds of brush strokes and ink tones employed in the painting.

Fig. 7 is a difficult example and it takes long practice to master enough skill to successfully execute it, because it requires the use of a combination of strokes. Always pay attention to how you enter, execute and exit a stroke and remember the importance of variation in stroke speed, pressure, ink tone and wetness as well as balance in the use of strokes to compose a painting.

Another technique used in Chinese painting is the *pomo* method (breaking the preceding application of ink), which consists of applying dark (light), wet ink over a preceding application of light (dark) ink before it dries. This method will impart a sense of lively variation and wetness to the painting. You can break light ink with dark ink or vice versa.

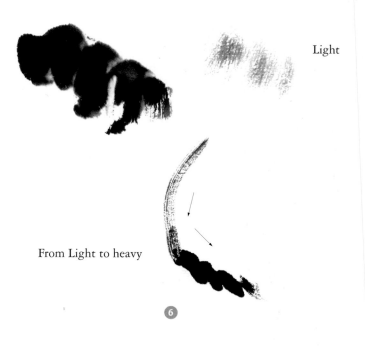

From wet centered-tip brush to dry side-brush

Light

From Light to heavy

6

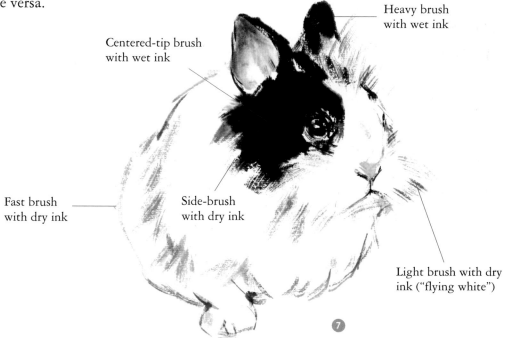

Heavy brush with wet ink

Centered-tip brush with wet ink

Fast brush with dry ink

Side-brush with dry ink

Light brush with dry ink ("flying white")

7